COLLECTING
AMERICAN
CRAFT
ANTIQUES

Also by William C. Ketchum, Jr.

Early Potters and Potteries of New York State
Pottery and Porcelain: A Collector's Handbook
American Basketry and Woodenware
A Treasury of American Bottles
Hooked Rugs
A Catalog of American Antiques
The Family Treasury of Antiques

COLLECTING

AMERICAN

CRAFT

ANTIQUES

William C. Ketchum, Jr.

Photographs by Everett Short
Illustrations by Gary Tong

E. P. DUTTON NEW YORK

For information contact:
Elsevier-Dutton Publishing Co., Inc.,

2 Park Avenue, New York, N.Y. 10016

Library of Congress Catalog Card Number: 80–66873

ISBN: 0–525–93129–5 (cl)
ISBN: 0–525–93130–9 (pa)

Published simultaneously in Canada by
Clarke, Irwin & Company Limited,
Toronto and Vancouver

10 9 8 7 6 5 4 3 2 1

First Edition

TO PAT . . .

CONTENTS

NATURE MATERIALS 60

HOUSEHOLD CRAFTS 80

PROJECTS 94

INTRODUCTION

Homemakers of the 19th century felt the liberating effect of labor-saving devices produced by the Industrial Revolution in a much more rewarding way than did the workers in mills and factories. No longer shackled to the stove and the loom, women who could (or more accurately, whose husbands could) afford the machines that took over washing, candle-making, and the manufacture of clothing found some real leisure for the first time.

How they employed this free time became a matter of concern not only to the women themselves but to their menfolk as well. Like children, women were regarded by some as beings whose hands, if idle, might wander into mischief. Accordingly, useful crafts were devised for or shaped to their entertainment. This attitude was clearly spelled out in *The Masterpieces of the Centennial Exhibition*, written by Walter Smith in 1876:

Work of this character [crafts] requires long practice and skill as well as instruction by competent individuals. But the general result is so satisfactory, and the work itself so thoroughly feminine that we sincerely trust that something of the same kind will be attempted in this country. We have a fancy that our lack of art schools and other

institutions where women can learn to employ themselves usefully and profitably at work which is in itself interesting and beautiful is one of the causes which drives them to so unsex themselves as to seek to engage in men's affairs. Give our American women the same art facilities as their European sisters and they will flock to the studios and let the ballot box alone.

Ah, if life were only so simple!

This, however, is but one side of the coin. Home crafts were much more than another subtle form of sexism. In the first place, the great majority of such skills were developed by women themselves for their own benefit. A pleasurable pastime was certainly a consideration in this, but often equally important was the age-old need to provide for the family. Hooked-rug and quilt making, for example, were hobbies in one sense, but they were also a means of providing needed floor and bed coverings. Decorative arts such as pottery painting, beadwork and paper cutting were more clearly leisure-time activities, but the objects produced often provided the only bright spots in otherwise drab frontier surroundings. In fact a very substantial number of the activities discussed in this book, including such pursuits as the making of wax flowers, alum baskets, and tinsel paintings, may be seen as attempts by the less well-to-do to duplicate or imitate expensive decorative items available to the wealthy.

Nor were crafts confined to women alone. Men also had their favorite free-time activities. Wood carving in its many forms, from the building of model ships to the making of tramp art, was a male hobby, as was pyrography for the most part. Such pastimes may have been even more important to men, since they often provided the only artistic outlet in a long life of hard work. While the distaff side grew up in a tradition of art and fancy work even if only samplers (or

rug braiding), males of the middle or lower class were often deprived of this; indeed, such efforts were traditionally regarded as "unmanly." Yet the need for self-expression would not be denied. A spruce gum box carved by a Maine logger or a cane head shaped by a prison inmate speaks eloquently of the deeply felt need to make something "pretty"—something that was not done for pay and could be cherished for itself alone.

The great crafts boom in post–World War II America reminds us all too clearly that such needs have not disappeared in modern society. They have, if anything, multiplied in the face of an increasingly impersonal technology. Men and women find their creative impulses thwarted by the mechanical nature of assembly-line work and turn to new outlets. They whittle model ships, hook rugs, and stitch quilts. These things, unlike the new automobile or washing machine, are clearly theirs, the products of their own skill and labor.

Collecting or creating, we continue to be fascinated by these crafts of the 19th century. They speak directly to us of our ancestors' home life and are tangible evidence of our roots in the American past.

COLLECTING
AMERICAN
CRAFT
ANTIQUES

WORKING
WITH WOOD

Today in our plastic- and metal-fabricated world it is diffi-
cult to realize the great importance of wood-based crafts to
the early American society. Nearly everything that was later
made of metal, glass, or pottery was at one time made of
wood. There were wooden bowls and wooden bottles,
wooden hooks and wooden hinges. There were even wooden
washing machines and plows.

This use of the wealth of the forest is not so surprising.
The early ships were small and could carry little besides
their passengers and the food to feed them. Metal, glass,
and pottery were heavy, and the latter two were fragile.
For many years metal and ceramics were very scarce, and
the imported supply did not begin to satisfy the demand,
while there were skilled wood workers among the pioneers
and excellent raw material was close at hand, so close in fact
that it was a nuisance that had to be cut down and removed
before any settlement could be established.

In Europe wood had been used for hundreds of years
to make everything from ships to inexpensive and durable
household utensils, and the settlers were quite familiar with
its properties and the ways to work it. Contrary to folk

tales about Indians teaching the white man to make wooden bowls and spoons, it is quite likely that the new arrivals were more proficient in that type of woodcraft than were native Americans. This was true not only of the trained coopers but of most of the male and some of the female settlers. In those days every boy was familiar with use of the ax and the barlow or jackknife, and this competency did not disappear completely with the gradual introduction of factory-made goods, even though metal, glass, and ceramics began to replace wood for efficiency. As long as the American economy was essentially agricultural, every farmer's son was frequently called upon to work with wood.

Given this background, it is hardly surprising that so many folk arts and crafts involved wood. Wood carving was carried on as both a business and a hobby. Professional craftsmen carved wooden shop and tavern signs, and the well-known wooden cigar-store Indians become representative of the carver's art. Smaller advertising figures for mercantile establishments were also popular, as were eagles and figures of Liberty for use on public buildings. Together groups of craftsmen worked on figureheads and pilot-house sculpture used on 19th-century sailing ships. Weathervane manufacture occupied another brotherhood of carvers.

Amateurs created their own weathervanes and wind toys, called whirligigs, as well as a variety of figures—from the religious Santos of the southwestern states to the crude penny-wooden dolls carved by loving parents for their children in the Appalachian mountains.

At first wooden objects were carved entirely by hand with the use of edge tools such as knives, chisels, and saws. But it was not long before the lathe was being used to turn pieces to shape, and the introduction of the jigsaw in the 19th century added another dimension to the wood crafter's

art. Despite these mechanical aids woodworking has essentially remained a handcraft. Duck decoys and model ships are still whittled by hand, and even today there are many people who take pride in their ability to shape wood.

WHITTLING

In whittling only a knife is used to shape the wood, and this tends to result in a limitation in size of the work produced. It would be needlessly difficult work to carve a cigar-store Indian with a pocketknife!

Whittling has been practiced in this country since the time of the first settlers. They brought the tradition to these shores, such handiwork having long been known in Europe. In the 19th century and well into the 20th century most boys had pocketknives and much of their spare time was spent in testing their blades on any wooden surface that might be available. This practice was so common in New England that Daniel Webster once termed whittling the Yankee boy's "alphabet of mechanics." Nor was the hobby abandoned with maturity. Few country scenes are more typical than that of the whittlers on the porch during the summer or seated near the glowing pot-bellied stove on a cold winter evening.

There are many reasons for this craft's popularity. Material and tools were easy to come by, and most people can acquire some modest skill with no great amount of effort or practice. Pieces may be copied or inspired from what the carver sees around him, or simply made up "out of his head," as a Kentucky whittler explained it. Whittling often begins with shaving a stick, curling thin slices of wood away, just

to pass the time. From this more complex items usually develop, as the whittler's skill and confidence grow. Susan Collins, a whittler of the 1940s, described the process very well: "I was as much surprised as anyone to see a little woman emerge from the wood; crude and funny, of course, but it made me want to try again; and little figures have been crawling out of sticks of wood ever since, each a little better than the one before."

Over the past two centuries a vast number of small objects have "crawled" out of wood under the encouragement of American whittlers. Many are representational. Human and animal figures, especially birds and domestic stock, have always been popular. Other creations are simply exhibitions of the worker's skills. Linked wooden chains and the seemingly impossible puzzle devices known as "balls-in-a-cage" have no pictorial significance; they simply are.

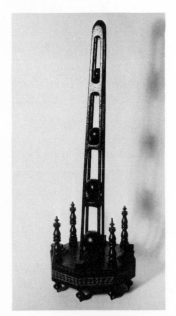

Carved whimsy, New Hampshire, *c.* 1880. The carving of puzzles such as this ball-within-block device was a traditional male pastime. Private collection.

Many objects are functional and are shaped to serve a definite purpose. Napkin rings, bread boards, and decorative wall hooks all filled a need. So did children's toys, such as miniature animals, slide whistles, tops, and dolls. Before the development of the American toy industry, and even today in rural areas, many children's playthings are those their parents or older children cut from scrap lumber. Wooden buttons, buckles, pins, and other jewelry are charming and still popular with sport and casual clothing. Whittlers may use any material available, including soft woods such as pine and tulip, but most prefer the smooth, close grain of fruit wood, maple, or walnut. Most whittlers leave their work unfinished or apply only a coat of oil or wax to the finished work. However, some workers paint or stain everything.

The basic techniques have changed little over the years, and whittled objects may be old or very recent, in the same style using the same design. As recently as the 1940s, when he was writing his *Handicrafts of New England,* historian Allen Eaton found hundreds of traditional whittlers working in the northeastern states. Since it is often difficult to tell old from recent work, the wise collector in this field looks more for a unique artistic quality than for evidence of great age.

As in all areas, there are super-stars, expert craftspeople in our era and in earlier times. The leading figure among 19th-century whittlers is the itinerant Pennsylvania carver Wilhelm Schimmel. During the last half of the 1800s, this man employed only his penknife to shape thousands of toylike birds and beasts of distinctive geometric forms. Sold for pennies in his lifetime or bartered for room and board, these simple pieces are highly valued today, many selling for hundreds of dollars.

Another great penknife artisan was Schimmel's some-time apprentice, Aaron Mountz (1873–1949), who also worked in Pennsylvania. But he produced fewer pieces, and his work is rare. Of course, great craftsmen like these are themselves a rarity.

The great majority of whittlers lived and died in obscurity, and their work, if preserved at all, is owned by collectors who know little of its origin. Whittling is an anonymous art, of and by the people, and it will no doubt continue as long as people enjoy the smell and feel of wood shavings and watching a creation emerge from simple wooden sticks.

CANE CARVING

The carving of walking canes is a specialized area of woodcraft and one of great interest to some collectors. The cane is an implement with a long history and a multitude of antecedents, including the shepherd's crook and various staffs that were symbolic of office or authority. Today few people use a cane unless compelled by age or infirmity. This was not always the fashion. As recently as the turn of the century, men carried canes as an essential part of dress. The collection of the Agriculture Division of the Smithsonian Institute includes more than 14,000 examples of canes.

Canes were made of many materials, such as bone, metal, glass, and pottery, but some of the most unusual specimens are of wood, hand-shaped with great care. Many of these canes were made for a specific person, as a gift or commemorative presentation piece to note a particular event, for example, the canes made from the timbers of Philadel-

phia's Centennial Hall at the time of its restoration. These commemorative canes were often highly decorated, and it was not unusual for them to be embellished with carved animal figures: lions, deer, dogs, cats, horses, eagles, swans, chickens, fish, snakes, or turtles. Human features were also used. Most of the faces used are unrecognizable, but the features of such famous people as George Washington and Andrew Jackson have been used as the heads of canes. Other unusual devices—hands, legs, shoes, flowers, trees, stars, hearts, and fraternal or patriotic insignia—were also used for cane handles and staffs.

In most cases only the head, which was often cut and carved separately before being applied to the cane shaft, was decorated. However, some of the finest examples of

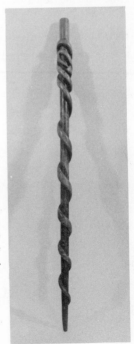

Hand-carved cane, Eastern United States, 19th century. Many men carved canes as a hobby, but few were skillful enough to utilize a natural form in this manner. Private collection.

cane carving feature overall carving throughout the length of the cane.

The most interesting examples of hand-whittled canes reflect the carver's knowledge of the properties of different woods and his ability to utilize natural grains and formations of the wood. The chance configuration of a branch or the peculiar twist of a root can be exploited to create an undulating body or a grotesque face. A young sapling about which a honeysuckle vine had twined might provide inspiration for the creation of a snake-wrapped walking stick.

Workers who utilized the natural forms of the wood would often cut a small tree slightly below ground level in order to preserve a portion of the root. The cane could then be made with the sapling serving as the cane shaft and the root as the head of the cane.

Most cane carvers left their creations in the natural wood or finished them with only a coat of varnish. Some, however, chose to paint the canes or even to add such decorative flourishes as porcelain eyes, silver end tips, or decorative banding.

Cane collecting is very popular, and a well-carved piece will usually be quickly sold, to be treasured in a collection. Very little is known of the men who created them. Few signed their work, and even fewer sold carved canes on a steady basis. Most were made as a hobby to be given away as gifts, and canes were seldom regarded as significant enough to justify commemorating either the making or the giving of the gift.

SPRUCE GUM BOXES

Unlike cane carving, a pastime practiced throughout the United States, the making of spruce gum boxes, another

branch of woodcraft, was limited to New England and the northeastern states and to a small group of craftsmen.

In the deep forests of Maine, New Hampshire, and Vermont, as well as the Canadian Maritime Provinces, a highly individualistic craft developed during the second half of the 19th century—the carving of miniature slide-top storage boxes. The makers of these novelties were professional lumberjacks who spent the long winter months cutting and trimming fir, spruce, pine, and larch logs, readying them to be sent down the rivers to the great coastal mills.

Sometime after the Civil War, these men began to employ their spare time in the making of small boxes shaped like books or barrels. These containers were roughly the size of the Big Little Books of the 1930s, approximately 4 inches high, 3 inches wide, and 2 inches deep. They were usually made of soft woods, though occasional examples in birch or maple can be found.

Like the sailors who made scrimshaw objects of whalebone because it was so readily available, the lumbermen's handiwork was of whatever materials were closest to hand. The finished wood box was carefully carved from a block of solid scrap wood, after the shape had been roughed out with an ax. Augers and chisels were used to hollow out the interior, and the exterior was decorated more or less with a combination of chip carving, inlay, and engraving. One or two sliding lids allowed access to the inside of the box.

Carving on the outside was done with the jackknife and on the inside with a curious local tool known as a "crooked knife." This device, supposedly developed by the Indians, consists of a shaped wooden handle bent at a right angle, to which a loose blade is attached to provide the cutting edge. The blade is usually made from a sharpened file.

Decorations were simple or lavish, depending on the skills and tastes of the maker. Some pieces were rough approximations of books or barrels. To add a note of realism, bindings or staves on miniature barrels were indicated by carving and by scratch-cut lines darkened through application of a hot wire. Other examples have most of their surface areas covered with meticulously done chip or gouge work. Against this decorative background may appear a variety of motifs including representations of human figures, woodland animals, fish, flowers, or trees, as well as geometric or symbolic devices like the heart, diamond, and cross. Since many of the woodsmen were Catholic French Canadians, the cross is frequently seen, and some boxes are clearly intended to represent a small Bible or psalm book. The engraved name or commemorative date found on the Bible is usually that of the recipient, rather than that of the maker. Like most folk artists, the gum-box makers most often chose to remain anonymous.

Though many of these small receptacles were left without finishing, most were varnished or given a covering coat of dark stain. A few painted specimens may be found, and these are regarded as highly desirable by collectors. Inlay in woods of contrasting colors is also prized.

Most spruce gum boxes, miniature books, and barrels appear to have been prepared as gifts for loved ones—mothers, sisters, or wives. They were originally intended to be filled with spruce gum, which is the pitch of the black spruce tree. Although it was not particularly tasty, spruce gum was plentiful in the forest, and it made a passable chewing gum. It was a popular treat until commercial brands of gum became available. Once the gum was gone, the containers served as mantel decorations and storage places for knickknacks, buttons, and other notions.

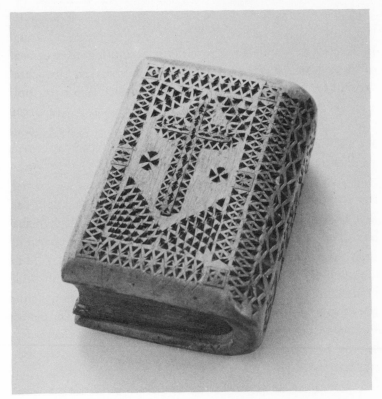

Spruce gum box, pine, Maine, late 19th or early 20th century. Small boxes of this sort were carved for wives and sweethearts by North Country lumberjacks. Courtesy, Milne Antiques, New York, New York.

With the vanishing of the great forests and the development of modern timbering methods during the 1920s, loggers no longer spent the entire winter in the woods. As the lumber camp passed, so too did the spruce gum box. Today's lumberman goes home at night to watch television, and the remaining spruce gum boxes find their way to antiques shops and collectors' cabinets.

TRAMP ART

In recent years collectors have discovered a whole new area of American antiques to which they have given the name "tramp art," although the term is not entirely accurate. It is a unique form of wood crafting, used for a variety of items from knickknacks to furniture, in which thin sheets of wood are put together in layers, then cut and shaped to create an illusion of depth.

A tramp art box, for example, would never be carved from a single block of wood, as a spruce gum box might be. The tramp art craftsman would take a box, usually a cigar box, and glue or nail to it other pieces of wood. He would then carve these to create a variety of levels and facets. Gouging and notch-carving are the basic techniques, just as in the making of spruce gum pieces, but the tramp artist goes much further. He may apply to the surface whittled or jigsaw-cut devices such as medallions, stars, hearts, and diamonds, or found objects such as pieces of broken glass, tin, cloth, or pottery.

Smaller items are left to weather to a pleasing brown, but often the larger pieces are painted in a variety of strong flat colors; red, white, blue, purple, and yellow are particularly popular. Silver and gold paint are also fairly common, or several shades may be applied together to create a colorist's nightmare.

The origin of tramp work is obscure. There are few dated American specimens before 1870, and the great bulk of the work was done during the period 1890 to 1940. There are no written references to the craft prior to the 1930s, when it was apparently being taught in some school shop classes. However, it seems likely that tramp art techniques were brought to this country by immigrant craftsmen

during the great wave of migration following the Civil War. The technique of chip carving, so central to this craft, was practiced in Europe throughout the 16th century, and similar decoration appears on 17th-century American oak furniture as well as on small objects such as pipes and salt boxes made in Pennsylvania during the 1700s. Since the so-called Pennsylvania Dutch settlers were really of Germanic background and since non-American tramp art has so far been found only in Germany, it is likely that the technique developed there.

In any case, by 1900 men and boys throughout the United States were constructing a vast array of objects in the tramp art style. The popular myth of a hobo sitting in a boxcar whittling out tramp art boxes and racks with his penknife is probably true to some degree. The tools and materials employed at the least complex level would certainly have been available to him. Nearly all tramp art is made of dismantled cigar boxes or fruit crates. These were easy to find and simple to carve. The rich red-brown of the cigar boxes was attractive in itself and did not require painting or staining.

The problem with the hobo theory is that much of the existing tramp art could never have been carried about by an itinerant or made with the tools available to him. Although there are many small items in the medium, such as lift-top boxes, pincushions, spool holders, salt boxes, doll furniture, and match holders, there are also sofas, bureaus, chests of drawers, tables, giant flowerpots, and even floor-standing radio cabinets. These pieces certainly had to be made in a woodworking shop or perhaps in an attic or spare room. Moreover, much tramp art, large and small, shows the marks of the powered jigsaw, an unlikely tool to be found in a hobo jungle.

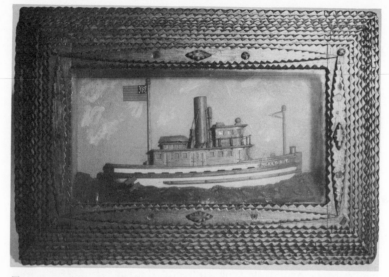

Tramp art picture frame or "shadow box" containing hand-carved ship model, New England, 20th century. Both the layering and chip carving characteristic of tramp art may be seen in this piece. Private collection.

Tramp art, then, was evidently created by many craftsmen, most of whom were probably working-class artisans who devoted their spare time to what they regarded as a hobby. The great diversity in the pieces found simply reflects the fact that these craftsmen attempted to duplicate in their chosen medium furniture and furnishings that they could not otherwise afford to own, and the sudden disappearance of the craft can be explained by the increase in personal income and decrease in free time occasioned by World War II. As the nation armed, people flocked to the factories. They had a new source of funds, but they no longer had the leisure to devote to tramp work. After the war other forms of recreation became popular, and tramp art took its place among the curiosities of the past.

SHIP MODELS

The making of ship models has naturally been most closely associated with coastal areas and the maritime trades. Sailors and the members of their families often whittled out representations of ships seen or served upon. Some of these "sailor-made" miniatures were crude in workmanship, but they were usually quite accurate in regard to details of hull shape and rigging, since their makers had been intimately acquainted with the vessels that served as their inspiration.

There is also a large group of professionally manufactured models that were designed as forms to be followed in the construction of full-size craft. These were generally prepared by ship's carpenters or architects associated with a boatyard and made to scale. Such examples are highly sophisticated and lack the naïve charm of the homemade types. After they had served their purpose, the professional models were often mounted on a wall or under glass to serve as ornaments to the quarters of a sea captain or the office of a ship owner.

There are several different kinds of ship models, each having its own particular appeal to a certain class of collectors. The half-hull or builder's model mentioned above is made out of a solid block of wood or several pieces joined and then carved to shape. It is usually only a mounted outline of half the hull seen lengthwise, perhaps with the masts in place. Unlike certain other miniatures, the entire hull, including the underwater portions, is constructed. The best known half-hull model is that of the racing yacht *America,* constructed in 1851 and now in the Mariners' Museum at New Bedford, Massachusetts.

Another form of working model is the framed half-hull. This is an open skeleton of a ship, lacking all or most

of its planking and decking. Such models accurately set forth the details of design to be followed in constructing the hull of a full-size sailing vessel.

The most detailed of the nonworking or hobby models is the built-up version. Here the craftsman constructs the miniature craft from the ground up, fully planking, framing, and rigging it just as would be done with a full-size vessel. Needless to say, many months may be spent on the making of a single model of this sort.

Rigged full-hull models look superficially like built-up examples with the important distinction that their hulls are carved out of solid wood rather than constructed piece by piece. Some full-rigged models are extremely large. A "miniature" copy of the sailing ship *Friendship,* made in the late 18th century by the ship's carpenter, was nine feet long. It ended up in a museum because it was too long to fit in its owner's home!

Rigged half-models are fully rigged representations of half a ship seen lengthwise. They are customarily mounted on a backboard with the sails and yardarms protruding horizontally out of this surface. Such pieces are often fitted with deep-set (shadow-box) frames three or four inches in depth. The base on which the ship rests, made of wood or putty, is gouged and painted to resemble the surface of the sea, and the backboard is decorated with representations of clouds and gulls. The overall effect is to create the illusion of a ship at sea.

The waterline model is a rigged full model which also rests on a sea of wood or painted putty. It is completely realistic and often built to scale to the waterline but left unfinished below. Such miniatures may have sails of paper, cloth, or carved wood.

Working ship models were usually made in a turner's

shop with a variety of sophisticated tools, but sailor-made examples were put together with little more than a jack-knife to carve the hull, a file to make the fittings, an awl, some needles, and some leftover paint. The makers of such models may have been professionals in the sense that they sold their creations or, as was often the case, simply ama-teurs who loved ships of all sizes. That this love exists today, widespread and undiminished, is reflected in the fact that not only are antique ship models in great demand but contem-porary models also find a ready market.

TEXTILES

No crafts practiced by the American woman consumed more time and effort than those associated with the making of quilts, rugs, and needlework. Before the construction of the objects themselves came the long and tedious process of preparing the materials from which they were made.

In Colonial times wool came from the family sheep or through trade with someone who had it to spare. The newly sheared wool had to be cleaned of burs and twigs with carding combs, washed and dried, spun, wound onto skeins, and then dyed.

Linen was made from flax grown in the fields. The complete process took sixteen months, including sowing the flax seed, cultivating, harvesting, removing seeds, drying, retting (rotting the stalks in water), further cleaning and drying, pulverizing, swingling (scraping to remove coarse fibers), carding with a heavy comb to reduce the fibers to a fine enough consistency for spinning into thread, bleaching, washing, and drying the thread preparatory to weaving.

And then, of course, after all this came the actual making of the cloth—wool, cotton, or flax—for use in making quilts, hooked or braided rugs, and embroidery. Small

wonder that before 1800 quilts were rare, embroidery a luxury, and hooked and braided rugs practically unknown. There probably just wasn't enough time in the day to make these items in addition to the family clothing.

QUILTS

Few crafts can compare with quilting as a communal and social activity. Probably most quilts were created by one woman working alone in her home, but for most of us this activity signifies the "quilting bee" and a half dozen or more prim matrons gathered about the frame, gossiping and drinking tea while they put together a quilt for the minister's wife or a young woman's hope chest.

It may be this quaint tradition, perhaps the beauty of the finished work, but, whatever the reason, few homecrafts are more generally appealing than quilting. The earliest can be traced to the late 18th century, and since then countless numbers have been produced in every part of the country. Even today, with all our technology and factory packaging, making a quilt by hand still rates high among female (and male) pastimes.

The concept of quilting—that two or three separate layers of cloth are warmer than a single one of equal thickness—is not new. In Asia clothing has long been made in this manner. However, it took American ingenuity to apply this principle to the creation of lovely bed coverings. The bold coloring and fanciful designs of antique quilts have made them favorites with collectors both here and abroad.

Quilts vary considerably in construction. Some of the most ancient consist only of three layers of solid cloth, or

two of cloth and one of batting, stitched together. A few rare examples may be made of stencil-decorated material, but for the most part early quilts are simply dyed in one or more solid colors. In such pieces the stitching holding the batting in place is the important decorative element. It is often extremely elaborate, reflecting the needlework skills of the maker as well as the long hours she spent creating her prize. Close examination will often reveal a remarkable array of stitched devices, including flowers, leaves, stars, and entire trees or plants.

Old quilts of this sort may be as much as three yards square with cut-out corners for four-poster bed posts. Sometimes there will be a border only on one side and one end, demonstrating the fact that in small cabins it was often necessary to push the bed into a corner, thus eliminating the necessity for borders on the concealed sides.

Another early quilt type that has persisted down to the present time is the appliqué, in which various forms are cut out of cloth and then stitched directly to the quilt cover. These can be quite fanciful, and truly unique examples, such as those that are pictorial in nature, are of great interest to collectors. One may tell the story of a Fourth of July picnic, another celebrate the marriage of a beloved son or daughter.

But usually when we speak of quilts, we mean the pieced or patchwork kind, where a varying number of textile pieces are seamed together to compose the quilt top.

Pieced quilts are the very essence of our native thrift. Many Americans alive today can recall grandmother's ragbag in which she carefully preserved bits and pieces of

Pieced or patchwork quilt, New York, *c.* 1880. This pink and yellow quilt is in the well-known LeMoyne Star pattern, many variations of which may be found throughout the United States. Private collection.

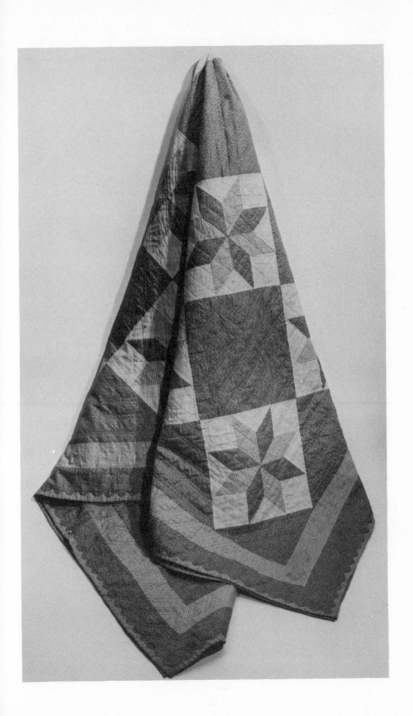

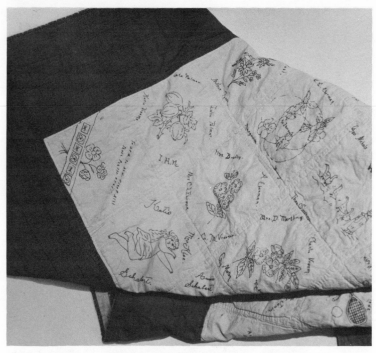

An unusual embroidered friendship quilt, New Hampshire, *c.* 1900. Quilts such as this one, in red and white, were often made as gifts for brides or the wives of local ministers. Private collection.

discarded clothing from which quilt patches might later be cut. While patchwork quilts vary in design, they always tend toward the geometric for the very good reason that it is far easier to sew together straight-sided pieces. Some pieced quilts may consist of but a few large sections while others will be made of hundreds of tiny bits of cloth, all stitched carefully together.

The choicest of these bed coverings are the friendship or album quilts in which the design incorporates various squares or patches contributed by different members of a quilting bee or social group. Often each square will differ in design and/or material, and generally the donor's name

will appear in India ink somewhere on the piece. This may be accompanied by a poem or some expression of endearment directed to the recipient of the quilt. Every friendship quilt is truly unique, and fortunate indeed is the quilt collector who can boast of such a specimen.

Also popular are the silk-and-velvet crazy quilts made during the late 19th and early 20th centuries. These are pieced together of all sorts of oddly shaped material cut from ball gowns and other fine clothing, and the stitching is typically elaborate. Many were designed as furniture throws rather than bedspreads. Silk and velvet are, unfortunately, quite fragile, and crazy quilts are often found in a damaged condition.

For many years quilts have been made from common patterns. As early as the 1870s *Godey's Lady's Book* and other popular women's publications were publishing standard designs, and over the years many have become household words. Such terms as Log Cabin, True Lover's Knot, Flower Basket, Wedding Ring, and Rolling Stone immediately bring to mind specific designs which have been reproduced countless times over the past century.

Other patterns are less common or may be associated with a particular state or locality. Lone Star, Indiana Rose, Kansas Sun Flower, Kentucky Patience, and Ohio Beauty are examples of designs whose popularity is greatest in a particular geographical area.

But to the collector, the one-of-a-kind quilt—the friendship, the pictorial, or simply the unique combination of shape and form produced by that one woman who chose to be different—is the real find. Today many contemporary quilt makers are taking that road, and modern specimens are often fanciful in the extreme. Pop art, op art, and various other expressions of modern art are being reproduced in

quilts, though not, I am glad to say, to the exclusion of the fine old traditional patterns.

HOOKED RUGS

Unlike quilts, hooked rugs are of rather recent origin. They seem to have first appeared in eastern North America, specifically New England and the Canadian Maritime Provinces, some time around 1800. They appear to bear some relationship to certain Scandinavian knotted rugs and to the "thrum mats" woven by sailors to protect rigging from high winds.

The technique, though time-consuming, is not difficult to master. Bits of old rag are twisted into one-foot lengths, then drawn through a coarse burlap backing by means of a metal hooking needle. The work follows a pattern either drawn on the mat in charcoal or previously printed on it, as with commercial rug patterns. Cloth of different colors is used for various portions of the design so that the rug's elements are kept distinct.

Unlike quilts, which are more or less standardized in size, hooked rugs appear in many different sizes and forms. There are full-room versions (though these are not common), half-moon-shaped entrance mats, round, oval, square, and rectangular examples, and even small circular chair seat covers.

All such rugs fall into three general design categories. Most common are floral pieces which embody various combinations of flowers, leaves, vines and branches. These were particularly popular in the 1920s and '30s, and vast quantities were then made. The best floral rugs are intended to

resemble fine European carpets, such as the Aubusson and Savonnaire. Some of the more elaborate examples may have certain portions hooked higher than the rest, or "hove up" as the old rug workers say. The contrast thus created is extremely interesting though sometimes a bit hazardous underfoot.

Although many early floral rugs were individual creations, most seen today are made from commercial patterns, the first of which appeared soon after the Civil War. Unfortunately, many of these factory designs are rather uninspired.

A second category of hooked rug, the geometrics, is enjoying great popularity at present. These pieces, whether made freehand or from a commercial pattern, are always based on combinations of geometric devices such as stars, circles, squares, rectangles, and ovals. These may be combined in an infinite number of ways to produce colorful and

Hooked rug, multicolored with red, green, and brown predominating. This Massachusetts rug, made about 1930, was done with the aid of a pattern printed on the burlap backing. Private collection.

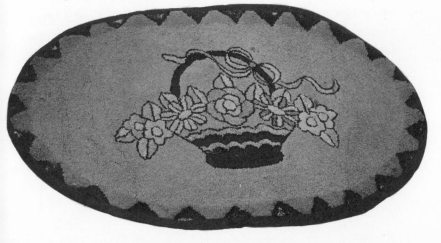

visually exciting patterns very much in keeping with modern design concepts. Nineteenth-century geometric rugs are now eagerly sought as wall or floor coverings, particularly as accent pieces with contemporary furnishings.

Perhaps of greatest interest are the pictorial hooked rugs, often produced with the aid of commercial patterns. Dogs, cats, birds, and horses are by far the most popular of the factory-made motifs, but many of the finest pictorial rugs sprang full-blown from the minds of the rug hookers, and resemble nothing clearly recognizable. A lion may look like a dog—or a dog like a lion. A chicken may be accompanied by a man half its size. Such pieces violate all laws of perspective and proportion, yet they have a charm which must be seen to be appreciated. So remarkable are some of these primitive rugs that examples have been known to sell for $1,000 apiece.

In addition to the animals that often decorate these rugs, there also may be sailing ships, locomotives, early airplanes, flags, clocks, fraternal and patriotic emblems, people, and even complete farm or town scenes. A charming naïveté often distinguishes the best examples.

Unlike quilts, hooked rugs may have been something less than a necessity in the early American home, which may explain in part their late arrival on the scene. Quilts were needed for warmth, but as late as the mid-18th century few Colonial houses boasted rugs of any sort other than rush mats or simple braided carpets.

The appearance of the hooked rug coincides generally with the introduction of factory-produced textiles. Now the frugal New England housewife, having a ready supply of material at her disposal, could bring herself to use precious cloth to make something intended to be walked on rather than worn.

Once material and patterns for hooked rugs became generally available, rug hooking became almost a mania in some areas. Although it was never particularly a social activity, it became an outlet for much of the pent-up artistic and creative ability stored away in the soul of the lonely farm wife. Just what that could mean to a woman is eloquently summarized in one rug maker's letter to the 19th-century *Rural New Yorker:*

I enjoy making my own designs. I never knew how to sing or paint or draw; no way to express myself, only by hoeing, washing, ironing, patching, etc., and while I never hope to accomplish anything extraordinary, I do love to plan out and execute these rugs that are a bit of myself, a blind groping after something beautiful.

That this need for self-expression is still with us is vividly reflected in the renewed interest in rug hooking, rapidly becoming a favorite indoor pastime pursued by men, women, and children.

BRAIDED RUGS

Probably the oldest of all American floor coverings is the braided rug. Primitive people made mats of braided or plaited grasses, and the floors of Colonial homes were often covered with layers of braided cattails or cornstalks. But the rough-board flooring and the harsh winters of New England dictated a more substantial covering, and it was not long before pioneer women were braiding their wool and cotton rags into thick rugs, soft and warm underfoot.

The widespread popularity of braided rugs is easy to explain. They are simple to make, require no tools other than a set of nimble fingers, and make use of materials

available in any home. Braiding is a process that even a young child can understand. Worn clothing such as gingham, denim, or woolen suiting is cut into long strips an inch or two wide. Three or more of these are pinned together and attached to a firm anchor such as a doorknob. The worker then braids or weaves the strands into a single unit. Other sections are subsequently joined by sewing end to end.

Depending on preference, the braided material may then be worked into one of several rug types. The earliest braided rugs were round or oval, since the ropelike strands of cloth could easily be coiled around themselves and sewn together from the bottom. Even today such rugs are popular, especially with beginners in the craft. More sophisticated craftsmen often prefer square or oblong mats or those whose center portions consist of parallel rows of braid running lengthwise or across the mat and surrounded by a conventional oval frame. Interesting variations include rugs woven around centers of hooked material or even sections of leather taken from an old coat.

Although most braided rugs are rather small, there are some examples eight or nine feet across. In New York City's old Dyckman House, which itself dates from the 18th century, there is a mammoth rug nearly twelve feet in diameter. Braiding a rug this size is truly an art, particularly since it is always difficult to sew the braiding in such a way as to avoid puckering or humping of the material—a problem compounded in larger rugs.

Color and pattern in the braided rug are limited by the medium. The earlier rugs show muted colors: tan, gray, green, brown, and black, reflecting the origin of the material in men's work shirts and old woolen suits. Later examples, particularly those of the post-1920 era, are usually brighter, either from a bath in garish dye or simply because they were

made from the lighter, brighter clothing favored in this century.

Contrasts in rug colors are usually rather basic. For example, a worker may vary the pattern by working with lighter material at the center of the rug and adding progressively darker tones as she works her way outward. New Hampshire rugs, for instance, often have an off-white center and a black border. Another common technique is to alter-

Circular braided rag rug made of cotton and wool. This rug was braided about 1925 in New York. It contains a half-dozen different colors. Private collection.

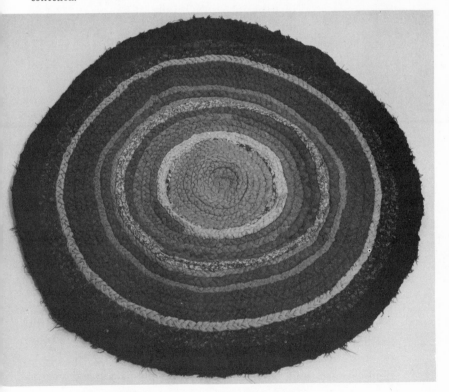

nate multiple rows of contrasting colors (three light, three dark, etc.) throughout a given piece.

Also, by clever interweaving of various colored materials, experienced craftsmen can work design motifs such as lattice work, serpentines, and ogees into their rugs. However, anyone who has spent much time examining braided rugs knows that such examples are not common.

In short, the braided rug is simple, warm, and lovable, a perfect addition to both the Colonial and modern home. Surely it must have been of these floor coverings that the poet thought when she wrote:

> With all around me beautiful I walk,
> With beauty above me I walk,
> With beauty below me I walk.

BERLIN WORK

Fine needlework was widely practiced by American women during the 18th and 19th centuries, but there were few who could create an interesting design. Delicate embroidery required a great deal of time and skill, and anyone who has seen existing examples can testify that the skill at least was often lacking. For many years this need was often filled by expert needlewomen who would lay out designs to be followed by their less talented neighbors.

Then, in 1805, a German print maker named Philipson drew a paper pattern for his wife to embroider. Within a decade engraved and hand-painted paper patterns had been replaced by ones stamped in color on canvas, called Berlin work after its place of origin. They became extremely popular in both Europe and the United States. Using the cross, double-cross, and tent stitches with various-colored yarns,

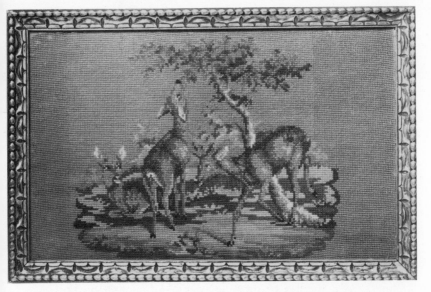

Hand-stitched wall picture of a type known as Berlin work, New England, *c.* 1900. During the Victorian era, pattern-based needlework of this sort largely replaced the more creative freehand work. Private collection.

women produced a spectacular array of needlework, all based on factory-made patterns.

Wool-work pictures—frequently copies of classical landscapes, biblical scenes, or portraits of heroic figures such as Washington and Franklin—were especially popular. An interesting variation was the wall plaque which embodied such aphorisms as "Bless This House" or "Welcome," carefully worked and framed in rustic walnut for display in the parlor or dining room.

Nor did the Berlin work enthusiasts stop with this. They covered furniture—sofas, chairs, stools, sideboards, and tables—with material stitched in decorative patterns incorporating the favorite flora and fauna of the 19th century. Flowers, fruit, parrots, deer, horses, leopards, cats, and dogs, including that great Victorian favorite, the

spaniel, appeared alone or in pastoral compositions derived from popular prints. Similar illustrations also can be found on smaller articles such as compacts, tobacco bags, purses, suspenders, and bookmarks.

In the 1870s it became fashionable to work cut-steel beads into the design as outlines for major elements. Some of these bead-decorated pieces are extremely interesting, although rusting of the metal has damaged some of the finest examples.

Today embroidery by pattern is so common as to be regarded almost as the "only way." In the 19th century it was truly a revelation and opened the field of embroidery to large numbers of women who might otherwise have confined their needles to darning socks and sewing on buttons.

ART-BASED CRAFTS

Until very recently the gap between artist and craftsman in Western society has been, in theory at least, a veritable chasm. The artist was trained in an academic structure. He attended classes on perspective, figure drawing, and color mixing. He saw himself as the inheritor of a long and noble tradition. He and his work were regarded by the rest of the populace as something set apart from the mundane aspects of society. On the one hand, both the rich (on whose uncertain patronage the artist's survival generally depended) and the poor often secretly suspected or even openly proclaimed that art was useless, without economic or social value. On the other hand, all tended to stand in awe of the artist's skills, particularly in those prephotographic days when only he had the ability to make a man immortal by drawing or shaping his likeness for posterity.

The craftsman, however, was seen in a very different light. He learned by doing under the guidance of a skilled senior whose talents had been acquired in the same manner. His work was by definition functional. A good bowl or piece of tin was a useful and often vitally needed thing. If he also was able to create beautiful objects, so much the better. But

in any case the determining criteria were does it work and is it cheap enough?

Nevertheless, many craftsmen, gifted with an artistic ability which they imparted to their products, took pride in making things that were both useful and attractive.

Women of the 19th century owed much to both the artist and the craftsman. From the first they received the tradition of formal academic training, and much that we now think of as "folk art" was actually produced under the guidance either of scholastic instructors or written directions prepared and sold by professionals. Thus, theorem and sandpaper drawings were popular elements of the curriculum in many early New England academies, while pottery- and glass-painting kits and instructions were available through popular women's magazines such as *Godey's Lady's Book*.

Other art-oriented skills were generally learned from craftsmen or skilled amateurs. Most silhouette cutters received their training at the hands of itinerant artisans, and the closely related art of *Scherenschnitte* (scissor cutting) was handed down from generation to generation in a few Pennsylvania families.

In all cases, though, the art-based crafts have the common characteristic of being founded in whole or in part on skills practiced by artists and craftsmen. The amateurs did not usually sell their creations but their work, if good, had the potential of competing directly or indirectly with commercial products. This competition continues today and is, ironically enough, often decided in favor of the gifted amateur. Thus it is not at all unusual for an unsigned theorem from the 1820s to sell at auction for more than an academic oil produced by a professional artist of the same period.

REVERSE PAINTING ON GLASS

Painting on glass can be traced as far back as the third century A.D., but with the introduction of quality stained glass in the Middle Ages, painting became a secondary art practiced primarily by local artisans and amateurs.

While glass provides a smooth surface and interesting background for painting, it has certain inherent disadvantages. It is, of course, fragile, and also paint does not bind well to the surface, resulting in chipping and paint loss. It was to solve this latter problem that reverse glass painting was introduced. A scene was painted from right to left on a piece of glass and from "in to out" in the sense that accent strokes and outlines were first painted, followed by shadows and highlights, the main areas of color, and finally the background. The whole process is the exact opposite of the procedure followed when working on canvas, wood, or tin.

Once completed, the painting was given a thick protective coat of white paint, turned around, and framed. The picture, in oil or opaque water color, was now protected from smudging or chipping by the glass on which it had been painted.

While reverse glass painting was popular on the Continent and in England throughout the 16th and 17th centuries, it did not appear in America until the 1700s. At that time European copies of classic themes, such as the four seasons, were imported in substantial numbers. But soon local artisans got into the act, and in the 1800s it was not unusual for a competent professional painter to produce more than 6,000 works in a single year. To this can be added the vast numbers created by talented and not so talented amateurs who found the craft an interesting pastime.

Classic reverse glass painting has always been done freehand with nothing to guide the artist's brush but his own taste and judgment. For those who wished to simplify and speed up the process, stencils and transfer methods were introduced at an early date. Stenciling may be confined entirely to the ornate gold-leaf borders surrounding some pictures, or it may be used for the entire composition as was often the case with the glass-panel paintings made to decorate 19th-century clocks.

Transfer printing dates back to the 1600s when English craftsmen began to apply dampened mezzotint engravings to glass. These were rubbed with sponges until the inked outlines of the engravings were transferred to glass made sticky by the previous application of turpentine. Once this was achieved, it was a relatively simple matter to add details and flat-paint areas.

American clock-case makers utilized engraved plaster plates to achieve the same effect, and by the 1860s mass-produced dry paper prints were being used to obtain a more rapid though less artistically satisfying transfer.

Often freehand and stencil painting were employed on the same glass, and one may even encounter pieces in which these have been combined with transfer printing. In the early 20th century it became customary to highlight reverse glass paintings with the addition of fragments of mother-of-pearl or tin foil. (Foil had already been employed for some years in making the so-called tinsel paintings discussed in a subsequent section of this chapter).

Generally, however, the earliest and the best reverse glass paintings were done freehand. Some of these were executed by artists well known in other fields. For example, the Prior-Hamblen school of American primitive oil painters, which was active in Maine and Massachusetts during

the first half of the 19th century, is known to have executed reverse glass representations of such heroic figures as Washington, Jackson, and Lafayette. Portraits of this sort were exceedingly popular at the time and are today among the most desired and most expensive examples in the field.

Indeed, legend has it that soon after Gilbert Stuart had completed his monumental oil painting of George Washington, an enterprising Philadelphia art dealer obtained a copy and sent it off to China to be copied many times over by that land's renowned (and poorly paid) glass painters. His plans for a major windfall were thwarted, however, when Stuart learned the arrival date of the ship bearing the paintings and bought them all up at wholesale prices before they could reach the public.

Portraits of statesmen are just one of the many subjects found in reverse glass painting. Ordinary men and women are portrayed, as are a variety of scenes from Revolutionary War incidents to the sinking of the *Titanic* in 1912.

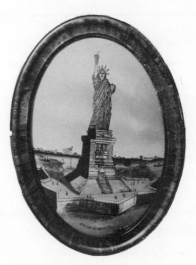

Reverse glass painting of the Statue of Liberty, New York, *c.* 1900. There are at least three variations of this theme, each of which can be roughly dated by the types of ships seen in the background. Author's collection.

Religious subjects were popular, particularly with Pennsylvania painters, as well as mourning and memorial paintings, and those featuring patriotic symbols such as the flag, the eagle, and the Statue of Liberty. There is also a great variety of purely decorative work ranging from simple florals to elaborate mythical landscapes. But perhaps no type of reverse glass painting is more popular than that which portrays an identifiable ship, balloon, or early train. Ships in particular were frequent subjects, though by no means as often as they were rendered in oil and water color.

While most reverse glass paintings are found framed or as decorative elements of clock cases, they were also popular components of mirrors, box lids, and trays. As with all paintings, some are better than others, but all represent an important stage in the development of American decorative arts.

TINSEL PAINTING

The art of tinsel painting is basically a variation of the reverse glass technique. The outline of a painting is sketched in transparent oil stains, with details such as fruit or flowers thinly colored. The surrounding background is done in opaque white or black, lampblack often being used during the 1800s. Colored tin foil, sometimes obtained from tea packages, is next crumpled up to produce a broken surface. It is then smoothed out again and applied as backing for the previously painted outline. The foil, seen through the transparent portions of the painting, gives the piece a jewel-like appearance.

For those who chose not to execute their outlines freehand there were prints that could be applied to the glass

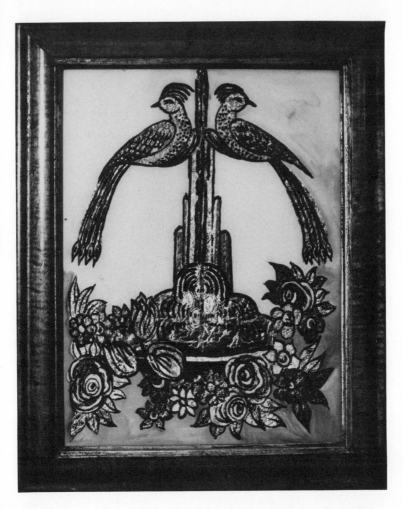

A well-done tinsel picture featuring Birds of Paradise. This is an example of the sort of work done in both the United States and England during the middle part of the 19th century. Courtesy, Ruth Berk Antiques, New York, New York.

and traced to achieve a similar effect. Also, in the late Victorian period, thin sheets of mica, which give an unusually brilliant appearance, and pieces of mother-of-pearl were applied as highlights.

In Europe such montages of colored tinsel and silver paper were known as pearl or oriental painting, or as *eglomise* after an 18th-century French practitioner, Jean Glomi. The earlier English examples were usually portraits of aristocrats and statesmen, professionally executed, but when the technique reached these shores in the mid-19th century, it became primarily the province of the amateur. These enthusiasts made few portraits, being much more interested in decorative pieces featuring birds, flowers, and still lifes, generally of fruit. While most tinsel paintings appear as individual framed pictures, box and table tops were occasionally treated in this manner but are now quite rare.

The best tinsel paintings are very good indeed, but unfortunately, most compensate in charm for a rather pronounced lack of originality.

CHINA PAINTING

Ceramics, like glass, present a smooth surface well suited to the application of oil paints or glazes, and the ornamenting of pottery and porcelain was one of the major decorative fads of the late 19th century.

Porcelain is an artificial compound rather than a clay found in nature (earthenware). It had been decorated in both Europe and the East for hundreds of years. The decorators were professionals, and their work was primarily underglaze; that is, the unbaked pottery was first decorated,

then glazed and fired. This was highly sophisticated work, and a slight error could result in a lost batch of pottery.

In the 1850s amateurs began to enter the field for the first time. In England and on the Continent groups of nonprofessionals began to decorate porcelain in the less demanding overglaze method. The color is applied to a previously glazed and fired piece, which is then refired at a much lower temperature merely to set the color. An Englishman, Edward Lycett, offered the first china painting class in New York City in the 1860s, and the hobby quickly spread throughout the country. By 1880 there were courses in ceramic decoration in all major cities, and young women's schools and seminaries regularly offered such training as part of their curricula.

One of the most popular instructors in this art was Mrs. A. H. Osgood of New York City, director of Osgood's Art School. In 1888 Mrs. Osgood's advertisement in *The China Decorator* (one of many periodicals devoted to the field) offered "painting on china—heads, figures, landscapes, flowers, fruit, fish, game. Pupils are supplied with original designs to copy from . . . twelve different designs . . . special instructions for fish." The fee for this instruction was one dollar for a three-hour session, not an inconsiderable sum at a time when day workers might realize no more for ten hours of hard labor.

China painting clubs flourished throughout the last quarter of the 19th century, and so important was the hobby that porcelain decorated by amateurs was exhibited with pride at the Philadelphia Centennial in 1876 and again in 1878 at New York's Academy of Design. Potteries such as the Willets Manufacturing Company of Trenton, New Jersey, found a profitable sideline in selling blank porcelain pieces for decorating. So active was this business in the 1880s

and '90s that special catalogs were prepared, listing hundreds of different blanks from two-inch-high vases to giant ewers more than three feet tall.

And this was but the tip of the iceberg. It seemed that nearly every woman and many men wanted to try their hands at pottery painting. But most were far from cities having courses of instruction, and only the middle class could really afford either the teaching or the porcelain blanks, which were never cheap.

For the others there were alternatives. Women's magazines offered articles, books were written on the subject, and both these and illustrated instructional kits were advertised in weekly newspapers throughout the nation. Small, indeed, was the small town that could not boast of at least one woman proficient in china painting, and, far from charg-

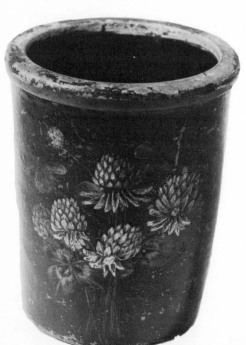

Still life in oils on stoneware preserve jar, Maine, late 19th century. Country painters, unable to afford pottery or porcelain blanks, painted on everything from stoneware jugs to glass bottles. Author's collection.

ing Mrs. Osgood's rates, she probably offered her expertise to her neighbors as a public service.

The problem of blanks was also dealt with. As early as 1879 Lycett himself had decorated stoneware pottery at a Liverpool, Ohio, kiln. Both stoneware and red earthenware were adapted to the role previously filled by fine china. Since few rural areas were likely to have kilns in which to refire the ware after decoration (and refiring of earthenware presented technical problems in any case), much of this painted pottery was simply decorated in oils and left as it was, essentially an oil painting on a ceramic background.

These less sophisticated renderings are often of more interest to collectors than the true china paintings. The latter were, as Mrs. Osgood boasted, generally copied from "designs," and these designs were generally European or Oriental in inspiration. Such pieces were neither truly original nor very American. The country paintings on stone and earthenware, on the other hand, are very much a part of the national heritage. The basic material was of the native soil, sometimes specially ordered blanks (since these were available in pottery as well as porcelain) but more often a discarded crock or jug pressed into service once more as an artist's canvas. The subject matter was as varied as the people who created it. Some were content to copy illustrations in magazines or to interpret Currier and Ives prints. Others created their own designs. Pets, home and farm scenes, still lifes, patriotic symbols, and bucolic landscapes— all these may be found on country "china."

VELVET PAINTING

Painting on cloth—velvet, silk, or satin—has long been

popular. In the 18th century it was known as Oriental tinting or Poonah work, referring to the city of Poona in India's Maharastra Province where the technique is said to have originated. The first known English reference is a chapter on the "Art of Painting on Velvet" which appeared in the 1805 edition of J. W. Alston's *Hints to Young Practitioners in the Study of Landscape Painting*.

Many early examples were done freehand, but far more popular was the technique of theorem painting, in which stencils of various shapes were combined to create a composition. The term "theorem" is sometimes defined as a relationship formulated in symbols, and this quite accurately describes theorem painting. It was less a free-wheeling artistic endeavor than the solution of a problem.

Stencils representing portions of leaves, buds, twigs, or whatever elements were necessary to the chosen composition were cut from "horn" paper—ordinary drawing paper stiffened by soaking in linseed oil followed by a coat of turpentine or varnish. These cutouts were then arranged in a design on a piece of white cotton velvet, and oils or water colors of a creamy consistency were applied over them with details added in India ink.

Although many artists solved their own "problems" or theorems and created their own compositions, far more worked by following patterns available from instructors in the art or printed in popular periodicals. One such pattern, that of a "Coloured Design for Damask Rose," appears in an 1885 copy of the *Young Ladies' Journal Complete Guide to the Work-Table*. It consists of dozens of tiny units which if properly colored will produce an elaborate flower.

Americans became interested in velvet painting early in the 19th century. By 1821 the *New York Commercial Advertiser* was carrying one C. B. Clayton's notice that he

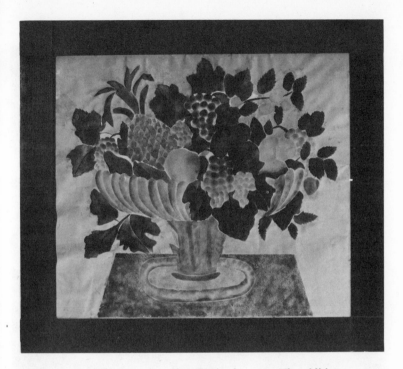

Theorem, or painting on velvet, New England, *c.* 1840. The addition
of cut work makes this theorem a bit unusual. Courtesy, America Hurrah
Antiques, New York, New York.

"has just received a few boxes of English colors for painting
on velvet warranted equal if not superior to any yet offered
in this country." The art was particularly popular in young
ladies' boarding schools, and training in such painting was
offered throughout the first half of the last century. In fact
many of the finest existent theorems have been traced to the
hands of students of various New England seminaries.

Well-done velvet paintings are quite lovely; unsuccess-
ful solutions to the problem are something else again. In
1833 the editor of the *Young Ladies' Assistant in Drawing
and Painting* dismissed the whole field with a flat statement
that "Frightful specimens multiplied until it has dropped

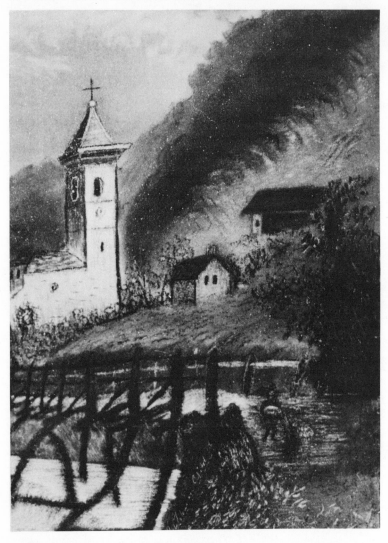

Sandpaper drawing, charcoal on sandpaper, Vermont, late 19th century. A popular Victorian pastime, most of these drawings are copied from European paintings or lithographs. Private collection.

into oblivion and is scarcely mentioned except in the country where painting has not made great progress." She was wrong, of course. Velvet painting continued throughout the 19th century. It had a revival in the 1880s and '90s and is now once again popular with craftspeople.

There is no doubt that the most sought-after pictures are those done during the period 1800 to 1840, highly stylized compositions, most often of fruit or flowers in a basket, occasionally landscapes. The passing years have dealt gently with these creations. Velvet that was once a shocking white has faded to a pleasing ivory or light tan, and the originally garish colors now have a charming muted quality. In some cases less permanent hues have nearly vanished, and stains and tears may mar the surface, but in general theorems survive in better shape than most early art work.

Late Victorian velvet painting is more lavish and much more naturalistic. The flowers look like flowers and the fruit like fruit. This, of course, is a "no no" among collectors of primitive art, and the paintings are unappreciated today. Like other Victorian memorabilia, they undoubtedly will come into their own someday.

SANDPAPER DRAWINGS

By far the least known and least appreciated of all art-based early crafts is sandpaper drawing. The products of this art—somber, mysterious renderings often featuring such Gothic excesses as ruined towers, sinking ships, and abandoned tombs—have found few fans in a society devoted to an optimism of light and color. Yet during the mid-Victorian period (1835–70) they were a popular form appropriate for hanging in the best drawing rooms and salons.

Sandpaper drawings were derived from the so-called "Grecian Painting," an English technique in which finely ground colors were applied with sponge and knives to simulate the color and texture of marble. The subject matter of these compositions was appropriately classic—Greek and Roman statues and temple friezes.

In the 1830s itinerant American painters modified this technique to avoid the time-consuming process of laying on and molding colors. At first, the paper or cardboard upon which they worked was coated with a sticky varnish and dusted with ground marble chips, emery, or pumice. At a later date a commercial sandpaper similar to the modern industrial product was employed. The granular surface was smoothed down and then drawn upon with common charcoal or, less often, pastel colors. A variety of tools, including sponges, cork, leather scraps, rubber, knives, wood, and bamboo, was used to create the drawing. In some cases tiny bits of moss, bark, or leaves might be added for a more naturalistic effect. The classic sandpaper drawing, however, lacked these embellishments and looked simply like a charcoal sketch, but charcoal with a difference. The marble or pumice-dust base produced a sparkling background which imparted an eerie, unworldly quality to the work.

Most sandpaper paintings were sprayed with a solution of steamed alcohol and sugar or alcohol and camphor to bind the pigments to the unstable background. All were intended to be exhibited under glass to reduce the loss of color and texture.

Sandpaper drawing techniques, introduced by professional artists, quickly became the province of the amateur. *Godey's Lady's Book* provided instruction in this area as in many others, and teachers of the art offered mail-order

instruction and "do-it-yourself" kits containing designs to be copied. As a result most sandpaper drawings found today are not "original"; they can usually be traced to an earlier painting or print. The usual route is from an oil by a well-known 19th-century painter to an engraving to a multitude of sandpaper sketches copied from the engraving. *The Night Storm,* a classic Victorian rendition of gloom and doom with sinking ship and lost souls, was painted in oils by Van de Velde, engraved by J. B. Neagle for the March 1838 edition of *The Ladies' Companion,* and then reproduced in the 1860s by a Connecticut sandpaper artist.

So popular was this craft that in the 1840s and '50s a family might gather for an evening of sandpaper sketching from commercially manufactured "drawing cards," each of which bore a classic scene. The cards would be shuffled and passed out in turn. Each member of the group would attempt to duplicate in charcoal the scene that had fallen to his or her lot. As a result, many sandpaper drawings have a distinctly classic (that is, foreign) appearance, and this has undoubtedly contributed to the medium's unpopularity with American collectors. Don't be deceived, though, for few European sandpaper drawings circulate in this country. There is simply not enough demand to justify importation.

Every one of these works should be examined closely, for a classical technique may often hide a native locale. Native artists often adapted traditional compositions to illustrate local scenes, and one may find stylized but accurate renderings of such historic sites as West Point, New York harbor, and Mount Vernon. Moreover, memorial pictures which were usually done in water colors or needlework are also found in this medium.

As a whole, sandpaper drawings offer one of the few

relatively untouched areas of native folk craft, and the wise collector who acquires them today will find himself ahead of a field in which interest can only increase.

CALLIGRAPHY

Today, with telephone, telegraph, television, and the type-writer, we tend to forget the importance that our grand-parents attached to handwriting. In those not-so-long-ago times when all out-of-earshot communication was by cor-respondence, the ability to write well was the mark of a cultured person. As important as expressing oneself clearly was the penmanship itself. The person who wrote a "fine hand" commanded immediate attention and respect.

It is not surprising, therefore, that penmanship was regarded by many and practiced by some as an art. As early as the 17th century, Spanish, Italian, and English writing masters had published textbooks on penmanship intended to assist the educated minority in developing a fine style. The illustrations in these volumes went beyond mere alphabetical exposition to instruction in the drawing of flora and fauna whose structure was based on the same linear elements as in handwriting.

The Germanic settlers of Pennsylvania brought with them a tradition of illuminated documents printed in a style known as *Fraktur*. These 18th- and early 19th-century pieces (primarily birth and marriage certificates) were done in a distinctly medieval style and were executed for the most part by trained scriveners who traveled through the back country performing this service.

What we have come to call calligraphy (though its practitioners never used the term) developed at a later date

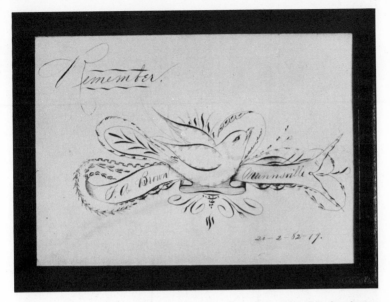

Calligraphy, ink on paper, Munnsville, New York, 1882. Directly related to Spencerian handwriting, calligraphic drawing was often used, as here, to embellish the autograph books so popular in the late 1800s. Private collection.

and in a different manner. Sometime prior to 1850, Platt Roger Spencer, a teacher and the founder of our country's first business school, developed a form of rounded, flowing penmanship that lent itself to decorative embellishment. Termed "Spencerian script" after its inventor, this writing proved an instant hit in the business world, in private academies, and in the newly developing public schools. Until well into the 20th century it was the standard for American penmanship.

Spencerian script is a fancy or cursive writing characterized by flowing strokes and joined letters, but it is much more than mere handwriting. Spencer's very first text contained examples (many of which were taken from *Pen's Triumph*, a 17th-century writing manual by Englishman Edmund Cocker) of figures that could be created by using

various elements of the alphabet. For example, the slanting lines in an *L* or a *W* and the circle of an *O* became units that one could combine to construct a horse, an eagle, or a flower garden. While most students never went much beyond adding a heart or two to a love letter, the quantity of existing pen art makes it evident that many tried their hands at calligraphic design.

In fact much of American decorative art was affected by Spencerian script. The cobalt-blue slip decoration on some American stoneware pottery of the period 1850–90 can be traced directly to this source, and valentines and other greeting cards customarily employed calligraphic devices. When we speak of calligraphy, however, what we generally have in mind are pictures. These are usually animal forms, though florals, houses, and even landscapes may be found. The work was executed with a spring-steel pen and India ink and sometimes lightly washed with water color.

There are three basic types of calligraphy. Most popular with collectors is that which contains elements of drawing and is, in effect, a pen-and-ink or water color. There are also somewhat abstract though basically pictorial pieces founded on the use of repetitive patterns and traditional figures. These florid drawings were intended to demonstrate the master's "command of hand" and often appeared in texts and in advertising materials prepared by those offering courses in the field. Finally, there is a category of ornamental writing employed in the preparation of diplomas, certificates and awards of merit, resembling, in purpose at least, *Fraktur*.

Spencerian penmanship was taught and utilized throughout the United States, but calligraphic drawing is rarely found in the South. The major source is the Northeast, especially Pennsylvania, with a substantial number of

Midwestern examples. The strongest work was done around the middle of the last century, the quality declining sharply through the 1880s and '90s.

Interestingly enough and unlike most crafts discussed in this volume, penmanship was almost exclusively a masculine form of endeavor. All the instructors appear to have been male, and the great majority of identified amateur practitioners also were male. Why this is the case we do not know, though it may well be linked to the fact that Spencerian script was first and foremost business writing, and in the days of its glory few women entered the business world.

SILHOUETTES

We have all lived for so long with the camera and the "instamatic" capture of fleeting human features that it is difficult to imagine a time when only the artist could provide a documentary immortality. Yet that period did exist and not so long ago. Throughout the first half of the last century, painters in oils and water colors earned a decent living doing portraits for all who could afford their services. But these likenesses were relatively expensive and took some time to prepare.

The silhouette offered a better way. In its most elementary form the silhouette is a shadow likeness cut by placing an individual between a strong light and a piece of paper tacked to a wall. The sitter's shadow, cast on the paper, is traced by the artist, then cut out and mounted. Initially, all tracing and cutting were done by hand.

Making of such paper portraits was a popular hobby in Europe during the 18th century, and unlike most of the

crafts discussed here, it was developed first by amateurs rather than professionals. It was, in fact, not until the 1800s that professional artists began to see in this pastime an opportunity to exploit the great demand for portraits at a reasonable price. When the working artist entered the field, he generally employed some version of the Physiognotrace, a semiautomatic tracing and cutting machine invented by a Frenchman named Chrétien.

The Physiognotrace usually consisted of a rectangular sliding frame to which was attached a movable stylus arm. The person to be portrayed sat on a stool in front of the instrument (which was backlighted) while the operator traced his features with the stylus. The outline, simultaneously reduced in size, appeared on a piece of black paper contained in a square receptacle at the top of the machine. The artist removed this paper and cut out the profile. The whole operation took but a moment or two. With such a device silhouette cutters were able to offer likenesses at a fraction of what painters were charging. Until the advent of the Daguerreotype photograph in the 1840s silhouettists effectively controlled the mass portrait market.

The first record of an American-made silhouette appears in 1799, when one Harriet Pinckney of South Carolina makes reference in a letter to her "shade" cut by the silhouettist Thomas Wollaston. It seems likely, though, that silhouettes were being made here prior to that time. Certainly by 1800 there was great activity in the field. Nearly every noted citizen had his or her "shade" cut. George and Martha Washington were done several times as were Franklin, Burr, Hancock, Lafayette, and many others. While some of these examples are by known professionals, many were also created by talented amateurs such as Patience Wright, the New Jersey Quakeress who cut a silhouette of Benjamin Franklin.

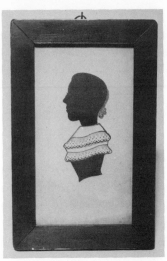

Silhouette, Eastern United States, 19th century. Cut paper with watercolor and pencil added. Prior to the invention of the camera, the silhouette was the cheapest and most popular family likeness. Private collection.

The earliest of these works tend to be the simplest (or, some would say, the purest)—a cut-out profile on darkened paper. It was not long, however, before decorative variations appeared. Moses Chapman, a professional scissors cutter of Salem, Massachusetts, pioneered a new technique, using the outer contour of the paper from which the silhouette was cut rather than the silhouette itself and backing it with a dark ground in cloth or paper. William Bache of Philadelphia developed "fringe painting," the sketching onto the silhouette and its background of details of dress such as collars, buttons, and ties.

The silhouettists did not long remain content with portraits. They did full-length figures, then groups, and from there moved out into the world of industry, cutting ships, trains and mechanical devices. The well-known silhouettist William Henry Brown, an anachronism in that he worked long after most of his fellows had succumbed to the camera and always cut by hand without aid of a Physiognotrace, once vividly described the variety of his own work:

In the author this faculty was not confined to the shaping of mere outlines of persons or faces, but was extended to portraying entire family groups, military companies, fire companies with their engines and hose-carriages, sporting scenes, race courses, and marine views, representing a harbor and shipping.*

Other famous American silhouettists included Charles Willson Peale, painter and museum owner, whose portraits (often marked MUSEUM, PEALE'S MUSEUM or PEALE) today command a high price; his nephew, Charles Peale Polk, who introduced gold-foil backgrounds for silhouettes; Samuel Folwell, who cut a well-known silhouette of Washington; William King, the inventor of the "Patent Delineating Pencil"; and James S. Elsworth, sympathetic portrayer of children and families. There was even a Miss Honeywell who, born without arms, learned to cut likenesses with scissors held in her teeth. Of this work a commentator once remarked that "it is naturally clumsy but marvelous that it could be done at all."

So many silhouettes were cut by so many artists that they are readily available on today's antiques market. Those that are signed or can be identified as having been cut by a known craftsman are expensive, but many reasonably priced anonymous works may be found. They are an interesting and attractive element of our national artistic heritage.

CUT-PAPER PICTURES

Less popular with collectors but a good deal older than silhouette portraiture is *Scherenschnitte* or scissors cutting, the art of making decorative designs from paper. Paper

* *The History of the First Locomotive in America from Original Documents and the Testimony of Witnesses,* William H. Brown, 1871.

cutting was practiced in China at least as early as the 10th century A.D., and the craft has remained active until the present time.

The ancient method required a skillful cutter who would draw a pattern. This would then be cut out and laid over a piece of thin paper which would be affixed to a flat board. Stencil and paper would be dampened and pressed flat, after which they would be held upside down over an unshaded candle or lamp. The soot from the flame would darken the paper and when the stencil was removed a white outline would remain. The patterned paper could either be cut out immediately or affixed to several other sheets so that multiple images might be obtained.

In ancient Europe religious groups cut and hand-tinted elaborate designs for everything from books to windows, and by the 17th century this work had become popular with the lay community as well. Both professional and amateur scissors cutters designed paper New Year's wishes and confirmation certificates which were highly regarded as gifts.

This tradition was brought to southeastern Pennsylvania in the late 18th century by Swiss and German immigrants, and much of the existing early American work may be traced to this area. The sisters of the religious society known as Ephrata Cloister used cut-paper stencils in the preparation of illuminated songbooks and religious tracts. Some of the most interesting 19th-century valentines were made in this manner, as well as awards of merit and complimentary bookmarks presented by teachers to deserving pupils.

Scherenschnitte was widely practiced in New Jersey and Ohio as well as Pennsylvania. The art was by no means, however, confined to a limited area. During the late 19th century scissors cutting became a popular lady's pastime, and

patterns printed in popular magazines were copied by women all over the country. The skill was also taught by private instructors and, to a limited extent, in female seminaries.

Many of the most sophisticated examples were created by itinerant craftsmen who wandered from town to town and farm to farm making a variety of decorative family records, house blessings, memorials, and presentation pieces for fraternal organizations. Unlike the amateurs who frequently followed prepared patterns, such cutters generally worked entirely freehand or from nothing more than a hastily prepared sketch.

These artists of the scissors seldom signed their work, and their output remains largely unidentified as to individual origin. Among the few known practitioners of the art are John Brown Walker, who was active in Pennsylvania, Michigan, Indiana, and Kentucky during the last half of the 19th century, and George Schmidt, who worked in upper New

This elaborate *Scherenschnitte,* or paper cutting, is dated 1856 and was purchased in New York City, although its origin is probably Pennsylvania. Watercolor highlights the central portion of the design. Courtesy, Annunziatta Antiques, New York, New York.

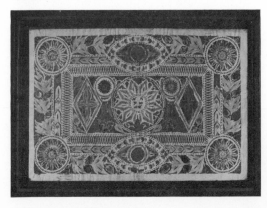

York State at approximately the same time. Both have left signed examples of their skill.

The makers of cut-paper pictures did not vanish with the advent of the camera. *Scherenschnitte* remains popular today and is practiced not only in Pennsylvania but throughout the nation. Much of the work is little beyond the strings of joined paper dolls cut by school children, but there are living artists whose creations rival those of the great European and American masters of a century ago.

NATURE MATERIALS

In a wide open country filled with fields and forests, it was understandable that Americans turned early to the use of natural materials in the making of craft products. Some materials, such as cornhusks for dolls and willow shoots for baskets, have been in use for hundreds of years; other resources, like shells and pine cones, were not employed until well into the 19th century.

One obvious reason for this difference is that basketry materials, for instance, served an important practical purpose in the pioneer home. They were essential to many aspects of life, and at a very early date all suitable materials were exploited. On the other hand, crafts based on such things as shells, hair, and fungi were essentially luxuries, pastimes that appeared during the great crafts development period of the 1870s and '80s. The Victorians, or at least the Victorian middle class, had far more leisure than their ancestors had ever known. Victorian women in particular put this time to good use in developing a variety of hobbies, many of which had to do with the creation of attractive objects from things found in nature.

Interestingly enough, the oldest and most essential

crafts have continued to flourish, while those that were more or less artificial developments have generally vanished. Basketry is a popular continuing recreation for thousands, but there are few indeed who can create or even recognize a feather work or a fungi picture.

SPLINT AND REED BASKETRY

When the first colonists arrived on these shores, they found the native Americans making baskets with techniques that they themselves were already familiar with. The Indians would cut down a strong-fibered tree, such as the hickory or the ash, and soak the trunk until it was soft enough to split lengthwise. They would then separate the fibers into long flat strips which were both strong and flexible. These strands, known as splints, could be woven into baskets and other items in either the crosshatch or the hexagonal weave.

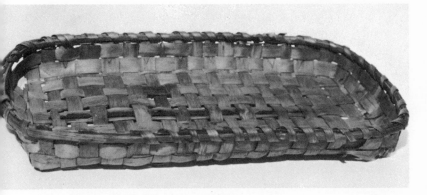

Splint fruit-drying basket, Connecticut, *c.* 1870. This container is made in the crosshatch weave, an easily learned basketry technique. Author's collection.

In crosshatching, the pieces of splint were crossed at right angles; in the hexagonal weave they were interlocked at approximately a 135-degree angle, producing six-sided rather than square openings. Crosshatch baskets had a tight weave and could be used for many purposes, while the open-work construction of the hexagonal receptacles made them most suitable for carrying things that required drainage or air circulation, such as fish and bulky farm produce.

The craft of splint basketry was extremely important to our economy, particularly in rural areas, until the end of the 19th century. Even after the process became industrialized, with splint cut and joined by machines, these baskets continued to be made by hand. In the hamlets of the Appalachian Mountains and along the Maine coast, basket makers still ply their trade, producing strong, well-made receptacles very like those made by their forefathers a century or more ago. Today much of their ware is sold to tourists or decorators, but a surprisingly large number of them find their way to farms and fishing fleets where they continue to perform their traditional tasks.

While some splint basketry, particularly miniatures, could be classified as hobby or amateur craft work, most such ware was, and still is, made by professionals, that is, those who sell their work. Such is not the case with willow baskets, which have long been the province of the hobbyist.

Willow baskets are made from the long, supple shoots of the young purple or Caspian willow. Long ago these shoots were trimmed to size by hand, but for many years they have been cut and shaped by specially designed machinery and sold in bundles of a uniform diameter. Willow strands are soaked to restore their flexibility and are then woven, most often in the crosshatch pattern, though many variations may be found.

During the 1800s so many willow baskets were made that farmers in New York, Pennsylvania, and Ohio planted their damp fields to willow trees and sold tons of shoots to factories that prepared them for weaving.

Willow basketry was popular as far back as the 17th century but was for the most part limited to a few different forms such as oval storage, wash and field baskets, cradles and bowls. By the 1890s other receptacles were serving these purposes more efficiently. At that time teachers of crafts became interested in willow-basket making as a recreational and therapeutic activity. Since then the weaving of willow has been a traditional free-time activity in schools, children's camps, and hospitals. Most of us remember those rainy days at summer camp when the long afternoons would be devoted to making table mats or what-not baskets of willow. These would be carefully stained or varnished and proudly presented to the family as proof of our creative activity.

Children are still making willow baskets, and a lot of adults are joining them. The durability of the material and the ease with which the skill is learned make this one of the more popular of contemporary leisure-time pursuits.

CORNHUSK WORK

The corn plant is, of course, native to this continent, and the first colonists found it cultivated and used in a number of ways by the Indians. The pioneers adopted some of these techniques and added others of their own devising, so that they were soon utilizing not only the corn kernels but also the cobs and husks, or shucks.

Even today, in isolated rural areas such as Appalachia,

corncobs are used for fuel or to make small pipes. The husks serve a number of purposes: as stuffing for mattresses or pillows or, more often, plaited and woven into chair bottoms, horse and mule collars, hats, and fans. Braided mats of several kinds, including large thick ones for floors and doorways and smaller versions serving as hot plates and containers for drying fruit, are common.

But the most popular of all cornhusk products, especially with hobbyists, is the doll. The Penobscot Indians of Maine are known to have made these quaint toys, and it seems likely that the settlers learned the art from them. The dolls may be made of a corncob clothed in husks or, as is more often the case, of wrapped and braided husks alone. Faces are drawn on in ink or natural stains, hair is composed of light or dark corn silk, and clothing is indicated by dyeing the husks various colors. Most dolls of this sort are three to eight inches high, though one may occasionally find larger versions. Due to their extreme fragility few early corn-husk dolls have survived, but contemporary specimens are still being made in the highlands of Kentucky and West Virginia.

SHELL ART

Shell art in its many forms has proved a most enduring craft. Mary Delany, a favorite of King George III, was famous in the 18th century for her shell-encrusted picture frames. Similar frames were made during the Victorian era and are still popular today. Their continuing popularity is explained

Cornhusk doll, Southeastern United States, 20th century. Dolls made of cornhusks and tassels were known to the American Indian and are still being produced. Courtesy, Rachel Ketchum.

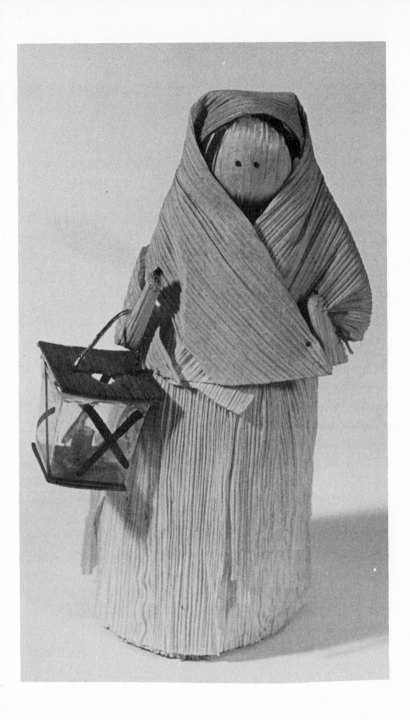

by the fact that shells are lovely to look at in their various shapes and are quite abundant.

The easiest way to use shells decoratively is to cover an object with wet plaster or glue and press them onto the adhesive surface in whatever order or design suits one's fancy. Shell-work picture and clock frames are constructed this way, as are a variety of trinket boxes. In the latter, the base is generally some sort of cardboard or wood container, often made in the shape of a bureau, a cottage, a slipper, or a star. Shell-encrusted pieces of this sort have been sold as souvenirs for a hundred years, and they typically bear a sentimental message such as "Good Luck" or "Remember Me." They have been extensively made in this country and abroad.

Closely related are shell mosaics or "sailors' valentines," as they are known in the United States. These are decorative arrangements of small shells contained within

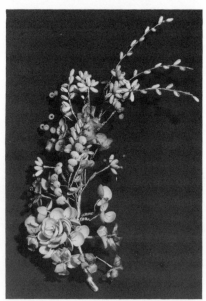

Shell bouquet, seashells and wire, New England, late 19th century. The use of fragile seashells to produce lovely bouquets was a sophisticated Victorian craft. Examples in good condition are rare. Private collection.

octagonal glass-topped boxes made in hinged pairs so that they may be closed. One section of the valentine is usually in the form of a heart or some other decorative device, while the other contains the usual sentimental platitude. Shell mosaics are older than shell-covered boxes, dating back at least to the 1820s. They have been collected with enthusiasm in this country in the belief that they are American sailor art. This, however, is doubtful. The shells of which these objects are composed are generally English or Mediterranean in origin, and there is strong evidence that they were made in southern Europe and the West Indies to be sold as keepsakes to sailors and other travelers.

More elaborate are the shell bouquets, arches, and wreaths. Bouquets first appeared in the early Victorian period and consist of fancy floral arrangements composed entirely of shells mounted on wire. They are often seated in shell-encrusted vases and mounted under a glass dome. Arches are made in a similar fashion but take the form of an inverted *U* and often appear with a model ship or perhaps a shell figurine. Shell-work wreaths or "pictures" are made of shells and seaweed in a variety of arrangements. They are mounted in cork or hardwood frames and hung as pictures.

During the 1880s women also made jewelry and hair ornaments from the tiny West Indian rice shells. These were extremely fragile, and few examples are found today.

Today shell workers may employ many different and spectacular shells from all over the world. The majority of 19th-century shell pieces, however, were manufactured from nothing more than the smaller varieties of the periwinkle family, mussels, and cowries. Variations in color were created by tinting the shells with paint or in some cases by removing the gray outer scale with acid in order to reveal

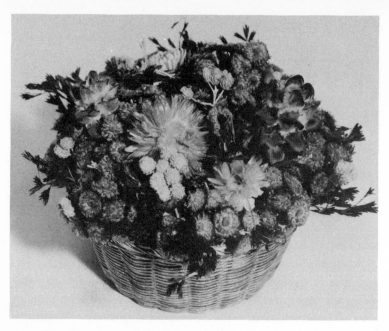

Bouquet of dried flowers, Eastern United States, 20th century. The most
elaborate dry bouquets were made during the 19th century, but the art is
still practiced today. Courtesy, Pat Sales Antiques, New York, New York.

the pearly iridescence of the inner shell. Elaborate instruc-
tions for such preparations appeared in *Godey's Lady's
Book* and other popular magazines.

DRIED FLOWERS

Flowers and leaves provided interesting material for the
craftsperson of the last century. No country holiday was
complete without the gathering of woodland flora which
would later be carefully pressed between leaves of blotting
paper for preservation in albums or within the pages of a
favored book, where their flattened forms might evoke that
morbid nostalgia so dear to the Victorian heart. While most

collections of pressed flowers followed no particular arrangement, some were assembled by species or organized into decorative compositions. In 1851 one such creation was presented to London's Great Exhibition by a group of New England women.

Those who did not care to keep the crumbling vegetation about the house might create silhouette facsimiles by pinning leaves and blooms to a light-colored piece of cloth or paper and spraying them with ink or water color. When the flora was removed, their outlines stood out against the tinted background.

There were more ornate arrangements of flowers and leaves dried in their natural shapes, then carefully mounted, often in a miniature basket, under glass. Shadow-box frames a few inches deep were used for this work, and the flowers were frequently supported against a wire framework. These compositions might be placed on a mantel or even hung on the wall as a picture. Examples of such work are rather uncommon today and are highly prized by certain collectors.

PINE CONE AND PINE NEEDLE WORK

While many of our crafts are, as we have seen, related to or derived from similar work done in other countries, the use of pine cones and pine needles as decorative material is uniquely American. The vast forests of this continent afforded a ready supply of raw material which was soon being tapped by artisans.

Cones of various sizes glued to picture frames provide interesting shape and texture. The cones, usually arranged in rows or decorative patterns, are shellacked for preservation. Such pieces were made throughout the 1880s and are

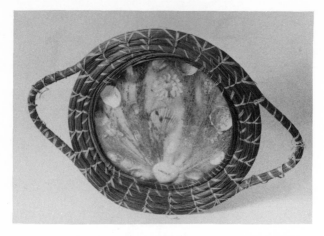

Serving tray framed in long-leaf Southern pine needles.
Trays of this sort were sold as souvenirs from 1920–40.
This piece is from Florida. Private collection.

Picture frame composed of various sizes
of pine and acorn cones, glued to
a wooden base. Eastern, early 20th century.
The craft of pine cone decora-
tion is once more popular with hobbyists.
Courtesy, Red House Antiques.

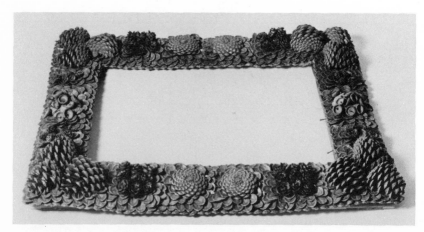

still popular among amateur craftsmen. Small pine-cone figures, sometimes mounted on wooden bases, are a 20th-century creation and clearly intended as souvenirs.

Needles, particularly those of the Southern or long-leaf pine, lend themselves to weaving and have been used as the basic material for such items as decorative trays and sewing baskets. The needles are gathered, dried, and soaked to make them pliable. They are then sewed into long bundles and woven by hand into various articles. The pine-needle industry, which was concentrated in the southern states, was especially active during the 1930s. Most examples found may be dated to that period.

DRIED SEAWEED AND MOSS COMPOSITIONS

The brown and sepia shades of dried seaweed are not particularly attractive to our eyes today, but the variety of delicate forms held a great fascination for our ancestors. Seaside vacations in the late 1800s invariably included trips to the beach to gather seaweed for drying. So common was this hobby in fact that in 1866 *Godey's Lady's Book* provided detailed instructions for obtaining choice specimens:

Go to the shore at low tide, after a blow from the sea. Best time is after the moon falls, for the tides are lowest then. Examine narrowly everything on the sand and rocks, and take up with your stick (which you had better have stout enough to steady your steps in passing over slimy rocks) everything you see that looks nearest like NOTHING. Then fish all you can of the same sort from the waves. Pick for the bright colors, but do not always reject dull ones. They often change to bright or at least deep hues after pressing.

Once collected, the seaweed was soaked in fresh water to remove the salt and then laid out to dry for storage.

Victorian moss and lichen composition, New England, late 19th century. Fragile and subject to decomposition, work of this sort is now quite uncommon. Private collection.

When the enthusiast was ready to mount his or her trophies, it would be soaked in water once more to restore form and flexibility and placed on a piece of oiled cardboard. After the minute filaments of the weed had been carefully separated and it had been rearranged in something like its original form, the mounted specimen would be pressed between two pieces of blotting paper and thoroughly dried.

Dried seaweed could be preserved in several different ways. Individual strands might be mounted on small pieces of stiff paper which were then linked with a ribbon and enclosed between two large scallop shells. Such seaweed albums were extremely popular in the British Isles but were not commonly made here. Amateur botanists in America generally pasted their specimens into scrapbooks, often accompanied by a notation of the date and place they were harvested.

A more craft-oriented approach was taken by those who arranged their seaweed in bouquets or wreaths under glass. The usual procedure was to glue the dried pieces flat against a paper or cardboard surface, but sometimes they were placed in shadow boxes, with a small basket cut in half and fixed to the background. This would then be filled with a seaweed arrangement, and the whole structure enclosed within the painted or gilded shadow box. In her *Art Recreations,* published in 1859, Mme. Urbino remarked of these baskets that she was "so happy to have one of them hanging in our parlor which does great credit to the artist, so beautiful are the combinations of colors and the delicacy and taste displayed in the arrangement."

Dried moss was also used in craft work, though to a much lesser extent. Moss was often glued to picture frames to achieve a rustic, textured effect. It was also, along with bark, glued to seascapes and landscapes (generally the gloomy Victorian renditions of ruined towers and sinking ships), creating an early form of collage. Painted rocks would be garnished with real moss; painted trees would show a strip of bark. The total effect was somewhat bizarre but clearly appealing to some, for the technique was revived in postwar Japan and is still practiced there.

FEATHER ART

In 1716 Boston needlework schools began to advertise courses in feather work, a somewhat complex craft involving the patterned arrangement of feathers. The earliest seems to be the feather picture, essentially an attempt to reproduce artificially the plumage of a live bird. The outline would be sketched on cream or green paper, and this form would then be carefully filled in with feathers appropriate to the

species, glued on in layers starting at the tail and working up to the head. A glass bead might serve as an eye. Extremely lifelike representations of birds such as pheasants, canaries, and thrushes were created in this manner.

By the 1800s hobbyists had begun to abandon such naturalistic creations in favor of elaborate feather flowers. These were constructed by bending the fibers of each feather over a penknife blade, causing them to curl. They would then be wired into place. Naturally colored feathers were used in this work, but it was also the custom to dye them exotic hues never seen in nature. As was noted in the 1890 edition of Beeton's *All Above Everything:*

Those feathers which have naturally no decided tint may be improved in colour taking care to use the dye which comes nearest to their natural tints . . . The first thing necessary is to put the feathers into hot water for a few seconds and to let them drain before they are put into the dyes.

Red, green, and yellow dyes seem to have been most favored. Feather flowers were arranged in several different ways. Some were made into magnificent bouquets or wreaths which were set in wax and mounted in baskets or vases beneath glass domes. Some of these were exhibited at the New York Crystal Palace in 1853, and women's magazines of that period carried detailed instructions for their creation. White goose or swan feathers were popular, and most were dyed prior to use.

Goose and other feathers were also cut into the shapes of flower petals and leaves and mounted on colored paper or black velvet in such a way as to create a relief effect. Such "feather pictures" ranged from floral compositions to rather abstract displays of color. They were framed in gilt or walnut and were quite popular in the late 19th and early 20th centuries.

Featherwork duck, feather, string, and watercolor on board, Eastern United States, early 20th century. Feathers were often employed to create realistic representations of birds, a much cheaper technique than taxidermy. Private collection.

Feathers were also used in the making of fans. Around 1850, fans of colored swan feathers (the so-called "Cora Fans") were regarded as a social necessity. A few years later elaborate peacock-feather fans with ivory handles embellished with hand-painted scenes were all the rage. In the same period feather-work bouquets and groupings often served as wedding-cake ornaments.

The enacting of state and Federal laws prohibiting the killing of many types of birds whose feathers were necessary to the craft brought an end to most feather work at the beginning of this century.

HAIR WORK

It may come as a surprise to some that human hair was one of the favorite craft mediums during the 1800s. By 1840, when the *Jeweller's Book of Patterns in Hair Work* was published, the making of hair jewelry was already a well-established avocation. Articles such as necklaces, rings,

bracelets, brooches, and lockets were made by braiding and interlacing strands of hair over specially prepared hollow forms, or frame works. These included such devices as hearts, crosses, flowers, fruits, and birds and could be purchased at the 19th-century version of the modern crafts store. Most were fairly large, but there were even tiny hair-work bracelet charms in the shapes of fish, horses, shoes, chairs, teapots and birdcages.

Rings and bracelets of hair were particularly favored. They were often made of a combination of human and horse hair (the latter for greater strength), and the plaited and twisted hair might be set with seed pearls and gold or silver fittings. Such pieces were made by professional craftsmen as well as by amateurs.

Hair jewelry, brooch of wire and hair, Eastern United States, late 19th century. Delicate jewelry of this sort was popular through the 1800s. Private collection.

Directions for the construction of hair jewelry appeared in an 1859 copy of *Godey's Lady's Book* and five years later in the equally well known *Petersen's Magazine*. Both articles reflected the interesting Victorian prejudices regarding this material. Black or blond hair was greatly preferred; brown was not in favor. As for the redhead, she had best seek out friends from whom to beg or borrow material, for red hair was totally unacceptable because of the Victorian belief that it reflected a "fast" nature!

Hair pictures, introduced in the 1860s, were another manifestation of the Victorians' morbid interest in death. They consisted of braided strands of the hair of both living and deceased members of the maker's family, woven into wreaths and mounted on a fine white satin background. Such hair work was preserved in plush-lined shadow boxes, which also frequently contained mementoes of the maker or her departed kin. As hair pictures became more popular, the interest in hair jewelry declined, possibly because the feelings associated with the two forms were so different. Today there is a revival of interest in jewelry made from hair, but the memorial pieces seem to have gone to their final rest.

BIRCH BARK SOUVENIRS

The flexibility and lovely color of the bark of the American white and paper birch trees made it a natural craft material. Small trinkets of birch decorated with glass beads and porcupine quills were being made for export to Europe by the northeastern American Indians as early as 1700. At first the business was handled by missionaries and trading posts, but after the War of 1812 the Iroquois of New York and the Micmac Indians of Nova Scotia took over the trade for their own benefit.

Indian bark work is quite varied. In the 1860s and '70s the output included cloth-bound birch table mats edged with beading and dishes with elaborate moose-hair embroidery featuring animal and bird motifs. By the end of the century these had been replaced by cylindrical cigar cases, small boxes for visiting cards (then a popular upper- and middle-class conceit), matchboxes, and picture frames. The Penobscot Indians of eastern Maine seemed to specialize in picture frames, producing them in various sizes and shapes.

In the 20th century, interest has turned to bark novelties—figures, tepees, and of course the famous birch-bark canoe. These are still being made today by both native Americans and non-Indian hobbyists.

FUNGI PICTURES

Nearly everyone who has spent any time in the country recalls the flat white fungi that grow horizontally from the

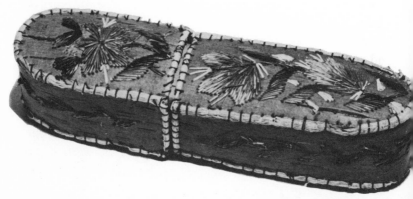

Lidded birch-bark carrying case, New England, 19th century. Probably made by Indians, this piece is typical of the bark work made for use and for sale to tourists. Private collection.

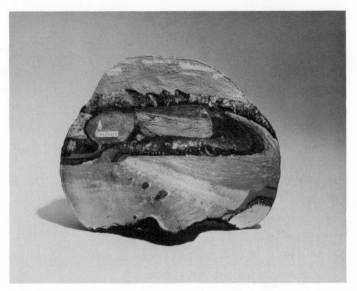

Painting in oils on dry fungus, Eastern United States, 19th
century. An obscure craft, to be sure, but fungi decoration is
not uncommon. Private collection.

sides of decaying trees. They break off easily and are just
as easily bruised. They are, in fact, a perfect writing surface,
as the mark of a stick or pencil stands out strongly brown
against the pale surface. Moreover, the marks remain, for
after a few weeks off the tree the fungus grows hard and dry
and will survive for years without rotting.

Sometime in the late 19th century amateur artists in
New York State's Hudson Valley put these characteristics
of tree fungi to artistic use by covering them with simple
sketches. Most show a single animal, usually a domestic one,
and they are surprisingly well done. Many seem to be by the
same hand, but no one knows what hand. Interest is now
turning to fungi pictures, and the question of who made
them may prove to be one of the more intriguing mysteries
of contemporary collecting.

HOUSEHOLD CRAFTS

Crafts people are, as we have seen, marvelously ingenious in the materials they can adapt to their pastimes, and in no area is this skill more evident than in household crafts. Women who worked with wax in the making of candles or the preservation of fruits and vegetables soon discovered that this substance could be molded or shaped to many attractive forms. Discarded newspapers could be soaked, glued, and pressed to make objects of papier mâché. Even such oddments as cigar bands or envelope liners could be applied to glass, pottery, or wooden surfaces to create interesting decorative collages. Cloth and glass beads could be blended in a number of ways, and drawing on wood with a piece of red-hot iron offered a variety of artistic alternatives.

For all these activities the materials were close at hand and relatively inexpensive. Unlike china painting or quilting, they required little training and no great amount of aesthetic sensibility. It is not surprising, then, that much produced under the heading of household crafts is of no great artistic merit. There are always exceptions, some remarkably lovely things that "just happened" through a happy blending of native talent and suitable materials. And even when such

miracles don't occur, one can still see in these simple craft objects an honest outpouring of love and sincerity.

PAPIER MÂCHÉ

Papier mâché—or paperware, as it was originally known in this country—is the product of an art nearly as old as paper itself. The Chinese began to manufacture paper in the second century A.D., and it was not long before they discovered that layers of wet paper, pulped, compressed, and glued together, produced an extremely light but durable material which could be bent and shaped to forms not attainable in wood and could be decorated to resemble everything from wood to tin.

The craft spread to Europe in the 17th century. The first factories were established in France and Germany, but by 1750 the British Isles had become the major European source of decorated papier mâché. In cities such as Birmingham and Wolverhampton hundreds of workers were employed to compress, dry, polish, lacquer, and decorate paperware. Much of this was shipped to the United States at prices low enough to suppress our own industry until well into the 19th century. Even today the bulk of the collectible papier mâché is of English rather than American origin.

The earliest examples in this material were made and decorated entirely by hand. The background was generally lacquered in black, though occasionally red, green, or yellow would be substituted, and the decoration was applied to this surface. The hand-printed floral motifs or landscapes were of high quality, and skilled workmen were paid as much as twelve cents per blossom, a great deal of money for an artisan in those days. As a result, papier-mâché products were quite expensive, but by the early 1800s inlay in silver, gold,

mother-of-pearl, or tortoise shell had become popular and could be applied at less cost. Around 1830 the introduction of transfer printing similar to that used in china factories further reduced the expense of papier-mâché manufacture, making it available to the general public for the first time.

Transfer decoration is a mass-production technique, reflecting the mechanization of the making of paperware. Giant steam-driven presses and forming devices were introduced to speed up the process, and the pulped-paper base was mixed with a variety of substances (everything from straw, hemp, and flax to sugar cane and pineapple leaves) intended to add strength and flexibility to the material. As the machines took over, individual creativity gradually vanished, leaving papier-mâché work during the late Victorian period primarily the province of the amateur.

The most popular papier-mâché objects were trays and hand-held fire screens (used to shield one's face from the heat of an open fire). Trays are found in many different decorative patterns and in the various distinctive shapes that serve to date them. Those of the 18th century are typically rectangular, while the ones made in the early 1800s (the so-called Chippendale trays) have a scalloped rim, and the later Windsor types of the 1850s are oval.

Both these items were often factory-made, but they were also popular with amateurs—one of the "ladies' amusements" of the 19th century. The homemade examples often were decorated with cutouts taken from colored engravings or prints and glued to the papier mâché, then lacquered or varnished for permanency.

Much more than this, of course, was made of papier mâché. Boxes of various sizes were common, and even furniture. While most furniture pieces were small—chairs and occasional tables, for example—someone once made a piano,

and there is even record of a paperware house. One must assume that it was intended for a desert climate!

PAPER PASTING

Perhaps the least complex of all early handcrafts was one that consisted simply in pasting tiny scraps of paper to various household objects. The art, if it may be called that, originated in France before 1850. There it was called *potichimanie,* from *potiche* (meaning glass or porcelain vase) and *manie* (mania or craze). Brightly colored drawings or paper scraps were pasted to the insides of clear glass jars and vases, and once an appropriate design was achieved, the paper was shellacked or varnished for preservation.

In some cases the work was intended to imitate the appearance of a piece of fine pottery. Thus an 1873 women's magazine commentator advised the housewife who lacked a porcelain vase to "make a potichimanie vase with her scraps; if grounded in pale blue or pink, it might be made to look like a Sevres vase."

Americans, always ready to improve on a design, carried this idea a bit further by producing lithographed sheets of colored motifs appropriate to various styles of pottery. These could be cut into sections and applied in such a way as to create a poor man's version of anything from a Ming ewer to a Staffordshire birdbath.

For those who could not afford commercial materials there were always bits of cut paper from the magazine color pages or embossed gold cigar bands. The latter were particularly popular during the period 1890 to 1910 when they were used in large quantities to decorate the undersides of fruit bowls and ashtrays. They were arranged in a formal pattern around a central figure—a small photograph of a

loved one or the likeness of a famous person. The cigar bands were glued into place and varnished or shellacked to protect them from wear.

Potichimanie and cigar-band ware were always designed to be protected by the glass through which they were seen, but there were other types of paper pasting in which the material was attached to the outside of a surface. In the 1880s pottery jugs and old bottles were often ornamented in this manner with everything from bits of old valentines to tinted fashion lithographs from *Godey's Lady's Book*. Jars embellished in this manner were known as "Dolly Vardens."

In the early 20th century, housewives often removed the colorful tissue linings from art deco envelopes, cut them into tiny squares and triangles, and applied them in a similar

Wooden box covered with cut and pasted paper, New England, late 19th century. Everything from wallpaper to envelope liners was used to decorate the surfaces of boxes, bottles, pots, and even furniture. Private collection.

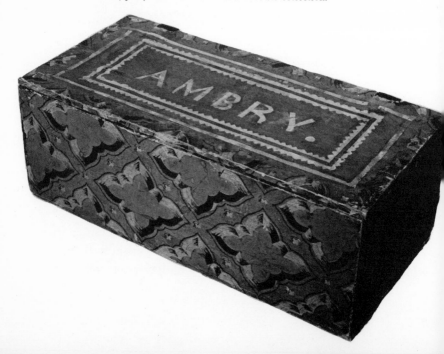

way to screens, boxes, and the tops of bridge tables. Such creations are not difficult to find today. On at least one occasion postage stamps were used this way: A late-19th-century ladder-back chair covered entirely with United States postage stamps was recently auctioned at an eastern sale. Had it been possible to remove these tiny bits of paper without damage, several of them would have been worth more than the chair itself!

BEADWORK

Small beaded items were among the most popular of Victorian souvenirs. As early as 1859 *Graham's Magazine* and *Godey's Lady's Book* carried detailed instructions for the design and manufacture of beadwork. Usually a piece of old flannel would be cut in the desired shape, and if intended for a pincushion or other piece requiring bulk, it would be stuffed with sawdust or cotton batting. A paper pattern was then cut to the desired dimensions, and multicolored beads, which could be purchased inexpensively or found about the house, were strung and sewn to the pattern and its flannel backing. Beads might also be threaded in chains and stitched on separately so that they dangled free.

Patterns might be created at home but were more often purchased from a shop or peddler. Designs tended to reflect the bucolic realism of the Victorian period, with flowers, trees, leaf sprays, birds, and pine needles predominating. Acorns may denote a Canadian origin for the craft was practiced there also, and the oak is a patriotic symbol for our northern neighbors. Geometric designs, popular in other areas, are uncommon in beadwork.

Beadwork pieces are generally small. Most commonly seen are wall pockets, pincushions, watch and needle cases,

Bead-decorated cushion, glass and fabric, New York, early 20th century.
Beadwork like this was done by Indians for sale, by others as a hobby.
Most come from New York, New England, and Canada. Private collection.

pen wipers, fans, picture frames, and coin bags. Since the
majority of these objects were intended as keepsakes, they
were likely to be preserved and are at present readily avail-
able for small sums. Most date prior to 1900.

One should distinguish between those examples made
for pleasure by Victorian hobbyists and the pieces that
the Tuscarora Indians of western New York and Canada
made for sale to tourists in the period from 1890 to about
1920. The Indians often employed identical patterns and
were, of course, masters at the art of beading. However,
their work is usually backed with a shiny cotton cambric
rather than the scrap-bag flannel of the housewife. They
also used a wool or canvas-net ground for their beadwork,
frequently working in bead motifs such as "Souvenir of
Niagara Falls" or "Happy Honeymoon."

WAXWORK—FLOWERS AND FIGURES

The unique properties of wax—low-temperature melting after which it can be worked by hand or cast, hardening to a durable shape—proved most attractive to old-time hobbyists. In the 18th century skilled artisans prepared portraits and figures of wax. Such work required a considerable amount of skill, and the product if sold was quite expensive. Although wax-figure modeling was practiced throughout the 19th century, it was soon surpassed in popularity by the making of wax flowers and fruit.

The heyday of wax-flower manufacture was signaled by the great London Exhibition of 1851. At that fair several large examples of the work were shown, and they attracted much attention. Women of all classes thronged to the hobby, while teachers, writers, and manufacturers of

Bridal bouquet of wax flowers, Eastern United States, late 19th century. Wax flowers are generally uncommon; examples such as this, made for a specific purpose, are even harder to come by. Private collection.

craft materials met them more than halfway. Among the many books on the subject published during the 1860s and '70s were Emma Peachey's *The Royal Guide to Wax Flowers* and Charles Pepper's *The Art of Modelling and Making Wax Flowers.*

Such texts were often sold along with complete flower-making kits which included as many as fifteen different specialized tools, as well as patterns, sheets of tinted wax, powdered colors, silk-covered wire, brushes, molding pins, mounting sticks, and a spirit lamp to be used to melt the wax. In both London and New York there were dealers who specialized solely in supplying materials for this craft.

Some hobbyists simply followed the easiest set of directions available and turned out botched and ungainly dust-gatherers, but for others the making of wax flowers was a high art. They carefully pulled apart such flowers as the fuchsia, the lily and the passion flower so that their components might be used as models. As one authority, Emma Peachey, cautioned:

The artist must keep perpetually before her the most exquisite and fragrant production of nature. She must study it with the same closeness of observation she gives when making a water-colour drawing, and she reproduces her flowers in a cleanly and pliable material.

The process of making these blooms was not simple. Sheet wax was carefully shaped and cut to resemble various parts of the flower. These were tinted as close to nature as possible and assembled with the aid of wire and wood colored to look like stalks and branches. The whole composition was frequently mounted in a deep glass-fronted shadow-box frame. While most of these frames were similar in form to those used for paintings, some were made in the shape of Gothic towers or covered with birch bark to add a pastoral effect to the composition.

The most painstakingly accurate work was undertaken in the creation of wax mourning wreaths. These were modeled to be exact copies of the real wreaths used at funerals. They were customarily framed to be kept by the family of the departed as a sad memento of his or her passing.

During the 1880s the casting of wax fruits became popular. Plaster of Paris casts were taken of apples, pears, oranges, bananas, and watermelon slices. These were then filled with hot wax and the product, when hard, was painted with oils. A popular Victorian centerpiece was a tinted-plaster compote filled with wax fruit. For longer survival these compositions might be placed under a glass dome. Small molds for animal and bird figures were also available. For a brief time at the end of the century, restaurants displayed wax replicas of the foods offered on their menus, a practice still current in Japan and other countries.

Antique waxwork is relatively scarce today. Much wax was melted down when the fad passed; other pieces melted when stored in hot attics or kitchens. Figures are particularly hard to come by, since most were very fragile to begin with. The cased or framed pieces, which were best protected and often most highly valued, have survived in the largest numbers.

CRYSTALLIZED ALUM

Fruit, waxed or real, was a traditional table adornment throughout the 19th century. The Victorian middle class was a charming mixture of the sophisticated and the naïve, the expansive and the frugal. European customs were much in vogue, and the alert hostess was always conscious of new trends from abroad. Thus it was that the popular Continental style of dining "a la Russe," or buffet, found ready acceptance in American homes. Central to this fashion was

the use of a sideboard in the dining room upon which would be displayed a sumptuous desert of fruit or pastry.

Old-world tradition required that these confections be displayed in bowls of Sevres, Dresden, or other fine china. But alas, few of our families could boast of such ware. So the clever American housewife created her own vessels from household materials. Among her products might be plaster of Paris or even wax compotes, but by far the most popular and most exotic were the baskets of crystallized alum.

Alum is a double sulfate of aluminum and potassium which has the interesting characteristic, when in solution, of adhering to objects placed in the liquid. Many 19th-century housewives took advantage of this trait in designing crystallized baskets.

First, a basketlike form was created by interweaving metal wire and winding this wire with thread or cord. Then alum was added to heated rain water until a saturated solution was achieved. This solution was allowed to cool until it had nearly reached room temperature, and the metallic basket form was immersed.

As the water cooled further over a period of some hours, the alum was precipitated out of solution and became encrusted on the basket in diamondlike crystals. These were dazzling enough in their natural state, and they also could be colored. The addition of such agents as saffron for yellow, logwood for purple, and copper nitrate for blue created a veritable king's ransom of gems—all fake, of course!

Crystallized-alum compotes were extremely attractive and very popular in their time, yet few can be found now. They were extremely fragile, and most did not survive the first day's festivities. What have survived are crystallized chimney or mantel ornaments. These consist of such things as twigs, moss, or flowers that have been suspended in an

alum solution, crystallized, and preserved by being placed under glass or in a shadow-box frame. They are not very common but may occasionally be found in museums and private collections.

PYROGRAPHY

Pyrography or "poker decoration," as it was once known, has a long and interesting history, longer perhaps than we can record. American Indians burned decorative designs on their birch-bark canoes and wigwams, and who knows for how long they had pursued that custom? Written references to poker decoration indicate that professional artists were employing hot irons to create burnt work at least as early as the 1840s. But using open fire and a red-hot piece of metal invited injury, and the craft did not really assume much importance until the 1880s when the development of the benzine vapor burner with attached stylus provided a relatively safe heat source.

Thereafter the technique spread rapidly from the studio to the home, and thousands of amateur craftsmen (and craftswomen) welcomed pyrography as a new parlor activity. As is usually the case in home crafts, the teachers and the suppliers of materials were not far behind. The October 1891 edition of *Art Interchange* carried a typical instructor's advertisement: "MISS OSGOOD, of the Osgood Art School (Broadway & 14th St. N.Y.) announces classes in BURNT WOOD (or as it is sometimes called Poker Decoration). This pastime has had a great vogue in England and is likely to be popular here."

Objects decorated through the pyrographic technique vary greatly in form and size. Most often found are ornamental wall plaques and pictures which may be anything

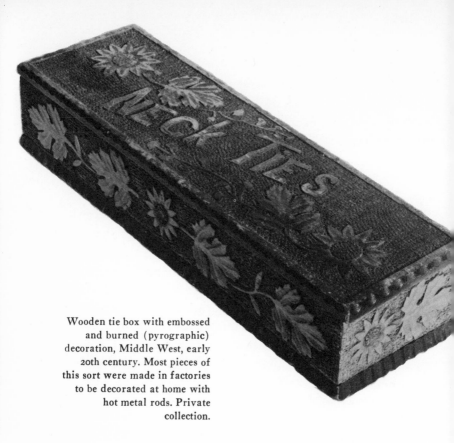

Wooden tie box with embossed
and burned (pyrographic)
decoration, Middle West, early
20th century. Most pieces of
this sort were made in factories
to be decorated at home with
hot metal rods. Private
collection.

from profiles of a Gibson Girl or an Indian chief to academic-
looking still lifes and landscapes. Boxes are also common, as
well as candlesticks, picture frames, napkin rings, string
holders, ink stands, mirrors, and personal articles such as
buttons, brooches, and hat pins. Though rarely found today,
large pieces of furniture also were embellished in this man-
ner: tables, chairs, umbrella stands, magazine racks, fire-
place screens, and even clock cases.

While such work was sometimes done freehand on soft
pine or basswood by creative individuals, the great majority
represents the painstaking copying of commercially stamped
designs. These were printed on precut blocks and sold in vast
quantities. As a result one often finds pieces that are identical

except for differences in the copyists' ability to follow a line. Still, variations are sometimes found even where standard patterns were employed. One hobbyist might deeply shade the background of his piece, while another might fill open areas with oil or water colors, or oil stains in natural wood tones. Some might even apply gold enamel or cheap glass "jewels."

Standard designs for use in pyrography appear to have been produced by quite a few different firms. The mark of the Flemish Art Company is seen on some examples; other well-known manufacturers are F. F. Frick and Company of Buffalo, New York, and Thayer and Chandler of Chicago. Most patterns produced by these concerns exhibit a distinct art nouveau influence reflecting the fact that the bulk of collectible pyrographic material relates to the period 1890–1920. At a later date electric burning tools and modernistic designs were introduced, but by that time pyrography had become a plaything for children rather than an adult pastime.

PROJECTS

WHITTLING A HORSE

At its highest level—as sculpture—wood carving calls for
rather specialized tools and a variety of woods. On a hum-
bler plane, the whittler employs a sharp penknife and what-
ever scrap wood is available to him. Certainly much of the
enjoyment to be found in carving small objects is that the
process seldom requires full attention. An experienced carver
will shape a figure while carrying on a conversation or tend-
ing anything from a flock of goats to a batch of kids. And
what he produces will often be a work of art—folk art.

Equipment and Materials

Traditionally, the whittler works only with a penknife,
preferably one with a slim blade 2 inches or so in length.
The blade must be kept sharp, and for this you need a small
whetstone and oil to dampen it. A chisel may be used for
roughing out forms, and sandpaper and linseed oil for pol-
ishing are desirable. The work may be finished with oil-
based stains, oil paints, or a good wax of the Minwax
quality. For our particular project, tracing paper will also
be necessary.

The wood used by carvers varies. Pine, cedar, and tulip are popular because they are light and easily carved. On the other hand, hard, close-grained woods, such as maple and walnut, are not so likely to splinter or split when worked and will take a better finish. Almost any wood can be utilized for whittling, and most carvers pretty much settle for what is at hand.

Roughing Out the Form

Select a piece of wood about 2 x 4 x 6 inches. Place a piece of tracing paper over the sketch of a horse shown here and copy the figure. Cut out the traced pattern and glue it to the piece of wood. Or if you prefer, a figure of comparable size may be cut from a magazine or newspaper illustration and applied in the same manner. Don't select anything too complex or with too many sharp turns to cut.

The figure may be roughed out by using a jigsaw, or by careful application of the chisel. A jigsaw is faster and easier. If a chisel is used, be sure to chip off small pieces, a few at a time, being careful to work across the grain of the wood to avoid splitting. Of course, you may carve the piece entirely by knife, but this requires much more time and a good deal of practice.

Shaping the Figure

Once a rough carved form is achieved, take the knife and, making sure that the blade is well sharpened, carefully whittle toward the outline. Use short strokes, cutting toward yourself and not forcing the blade. Do not attempt to remove more than a small portion of wood with any one cut. For the most part, cuts *with* the grain, providing they are controlled, will be easier and will remove more wood. But they risk splitting the material, so work slowly and round the figure as you progress.

When a section is completely carved, use sandpaper to smooth the rough edges and finish the area. It is particularly important to sand tight areas, such as those under the neck or between the legs of the horse, as it is difficult to get the knife blade into such spaces without running some risk of splitting the wood.

Once all the carving is completed, the figure should be sanded all over, then oiled to seal and protect the wood. At the very least the wood should be waxed. Apply a thin coat of good-quality wax, allow it to dry for a half hour, then polish briskly. If you wish to finish the horse in natural tones, commercial oil stains may be used, and these can then be covered with a coat or two of shellac mixed at a ratio of 1 part clear shellac to 5 parts solvent. If you want to create a specific type of horse, an Appaloosa or a bay mare,

for example, paint the piece with oil paints approximating the coloration of your choice of horse.

A TRAMP ART BOX

For more than fifty years boxes, frames, and various other small objects with chip-carved and layered exteriors were made throughout the United States. Changes in the use of leisure time and a decline in the availability of cigar and fruit boxes—the tramp artist's main source of raw material —have made the hobby less popular. But for those who still pursue it, it can be a creative use of spare time.

Equipment and Materials

As in whittling, the tramp art worker's basic tool is the penknife or a single-edge razor blade. If a knife is used, one should also have oil and a whetstone. A ruler, pencil, sandpaper, white glue, and oil-based paint or stains are also desirable.

The basic form, a box, may be either an old cigar container of mahogany or cedar (both are close-grained, easily cut woods of an attractive color) or a basswood box of the sort readily obtainable at any craft shop. One will also need several sheets of clear, soft wood such as pine or poplar. These should be about ½ inch thick.

Chip Carving

All true tramp art relies heavily on the chip-carved surface for its decorative effect, so it is necessary first of all to learn this skill. Follow the accompanying diagrams carefully.

Draw on the top and each side of your box rectangles with 1-inch-wide margins. Then cut pieces of sheet pine the size of these rectangles.

Select one of these pieces of cut pine and, using ruler and pencil, draw a grid of ½-inch squares over its entire surface. Divide these squares into triangles with the addition of diagonal lines. Hold your blade at a 45-degree angle to the wood, with index finger of the cutting hand near the blade tip. Use your free hand to steady the wood.

Starting at the top of line *A* on the illustrated triangle, cut down this line until you reach the bottom corner of the triangle. Remove the blade and rotate the piece of wood

so that line B faces you. Now cut line B in the same manner, followed by line C. If the first cut does not completely loosen the chip on any one side, firmly recut that area following the original line. The cut-out triangles should slope toward the center and be clean with no excess wood within them.

Once the first triangle is finished, proceed to cut the other three in the square. The result should be a shallow cut-out carving in the form of a four-pointed star. If any portion of the design should chip off in the course of carving, it may be replaced with white glue. Continue to cut out the entire surface of the board, square by square.

When the piece is entirely carved, it should be glued into place on the side or top of the box, as appropriate, and the same process followed with the remaining four sections. The 1-inch-wide margins on the box may also be chip-decorated, or they may be left plain for contrast.

Although our example calls for only two layers of wood, it was not unusual for a tramp art worker to stack up to a half dozen chip-carved boards, one on top of the other. The effect could be very pleasing.

Once all portions of the piece are cut and glued together, the surface should be lightly sanded. Do not try to sand the interiors of the chip carvings.

Finish is optional. Mahogany and cedar are both warm red-brown in color and quite attractive in their natural state. A bit of linseed oil to feed and seal the surface may be quite sufficient for them. However, if you have used white wood, such as pine or poplar, it can be stained or painted. Oil stains may be purchased in colors such as mahogany, walnut, or oak, and these cover well.

Earlier makers of tramp art often used oil paints or gold and silver gilt to decorate their pieces, and you may wish to add such a finish. They also liked to glue all sorts

of odds and ends—shards of glass, bits of tin, buttons, and even pictures—to their work. This may be a bit too Victorian for modern taste, but if desired, the materials can readily be found.

THE PATCHWORK QUILT

The patchwork quilt is the least complex of all quilts and one that lends itself to a variety of designs. Patchwork, which could really be called "scrap work," is a fine example of the thrifty American housewife's ability to recycle her textiles.

Equipment and Materials

Scrap material such as cotton, linen, silk, or wool (and compatible synthetics or blends), washed and ironed; a short, sharp needle, #8 or #9; white sewing thread, #30 to #50; a ruler; scissors; pencil; and stiff, thin cardboard for patterns. A sewing machine is helpful, though many quilters prefer to do everything by hand; a quilting frame or hoop is optional. You will also need cotton or wool for backing and cotton or polyester batting in the same size as your quilt.

Preparing the Patches

Quilts are composed of three distinct sections: the top, the inner batting, and the back or lining. The top is made first and is the most important and creative element of the piece. In a patchwork quilt this top is composed of many small individual pieces of cloth which are cut in various shapes and then sewed together.

The quilt we are making is in the diamond pattern. It is among the most attractive of all traditional quilts and not difficult to make. To begin, trace a diamond form (about 4 inches by 4 inches) on a piece of stiff cardboard, then cut

it out. If handled carefully, this master pattern can be used repeatedly.

Select a piece of material and press it out smooth, then apply the pattern to the "wrong" side of the fabric. Using a light pencil or chalk on dark cloth and a dark pencil on light, carefully trace around the pattern. Repeat this as often as necessary and as cloth is available. Be sure to leave at least ½ inch between pieces for a seam allowance.

Use material of several different colors and patterns, and as you cut out the patches separate them according to color. You may find it convenient to string each color group individually by running a single strand of thread, knotted at an end, through their centers.

Piecing

To sew the individual patches together hold them firmly, right sides facing; then stitch them together with small running stitches, following the previously marked outlines. End each section with a few backstitches for added strength. If the fabric tends to bunch as it is put together, excess material at the seams may be trimmed. Where two bias edges come together, thread should be kept just tight enough to prevent stretching of the seams.

Alternate pieces of different colors and patterns as you wish in order to create an interesting overall design. The quilt may be as large or as small as desired, since geometric quilts may end at any point without unbalancing the design.

Quilting

Once you have pieced together enough individual sections to make a quilt of the desired size, press the completed top. Keep the seams to one side, as open seams will weaken the structure of the quilt.

Next put together the top, interior batting, and lining.

patch

quilting stitch

The lining or backing should consist of a single piece of fabric, preferably cotton or wool, that is the same size as the quilt top. Cotton or polyester batting may be purchased in bulk at most dry-goods stores. The more layers of batting the warmer the quilt will be, but it will also be bulkier and more likely to shift and break seams under stress.

To assemble, place the lining "wrong" side up on a flat surface such as a floor or table top. Put one or more layers of batting on top of the lining and smooth out any lumps that may develop. Anchor the batting to the lining with long running stitches across the whole of the material.

Now place the quilt top over the batting right side up and pin all three layers together. Unite all layers with basting stitches to prevent fraying. It is best to baste diagonally in the form of an X as well as around all four sides.

If an edging to the quilt is desired, this may be made

by cutting the lining ½ inch wider than the thickness of the batting on all sides and ¼ inch wider on the top. When quilting is completed, excess lining may be turned over the batting and stitched in place. The extra ¼ inch of the top may likewise be turned in, and the folded edges may be slipstitched together to form a firm edging.

The purpose of quilting is twofold: to bind all three layers of the quilt firmly together and in some cases to add an attractive decorative element to the piece. Quilting may be done either with a sewing machine or by hand. Machine quilting works best when done on the bias or the diagonal, while hand stitching may take any form or direction.

In making this quilt follow the diagonal pattern shown. As you can see, this pattern accommodates suitably the diagonal lines of the diamond-shaped quilt pieces, and the quilting stitch may follow the sides of the diamonds. This makes it easy to stitch on a sewing machine, which will save you a good deal of time.

If you do use a machine, use a straight stitch with 6 to 12 stitches per inch, and set the pressure at a point slightly more than that used with medium-weight fabrics.

If you choose to quilt by hand, follow the same diagonal pattern with short, even, running stitches. Push the needle down through all three thicknesses of material, then up again close to the first stitch, while keeping one hand under the quilt to guide the needle. Generally, 5 to 9 stitches per inch, depending on fabric thickness, will be appropriate. End each section with a backstitch, running the thread through the interlining. For large areas it would be wise to use a quilting frame.

Once completed, the quilting will hold the batting firmly within its textile envelope without slippage even when the quilt is being dry-cleaned or carefully hand-washed. It

also provides an interesting decorative element to the overall design.

HOOKING A SMALL RUG

Rug hooking is the most truly native of all American textile crafts. The materials required are readily available, and the technique may be learned and practiced even by a young child. Small wonder then that "ruggers" are among the fastest-growing groups of American craftspeople.

Tools and Materials

The only tool required in rug hooking is a hand hook resembling a crochet needle with a wooden handle, obtainable at crafts or needlework stores. More sophisticated semiautomatic hooks may also be used. Some experts prefer a true crochet hook or even a large bent nail!

Foundation material of burlap (the usual choice) or linen, the latter known as "warp cloth," may be purchased by the yard from craft or textile suppliers.

Although not required, an adjustable rug frame to work on will be helpful, particularly for beginners. These are also found at craft stores.

The body of the rug is made from commercially manufactured wool or cotton rug yarn or from strips of old fabric cut to size. The hand-cut fabric was common in an earlier age, but most modern rug makers prefer the inexpensive and easily obtained yarn.

Scissors, a ruler, pencils, and tracing paper may be used as required.

Making the Rug

If you decide to use cut cloth in your rug, the first step is to

plate

prepare this material. Width of strips will vary according to the thickness of the cloth. Closely woven fabrics may be cut to a width of as little as $\frac{1}{16}$ to $\frac{1}{8}$ inch, while coarser textiles may be as wide as $\frac{1}{2}$ inch. The strips should be uniform in width and no more than 12 to 16 inches in length. Cutting should be done on the straight grain of the material with ordinary scissors or a special cutting machine available at most needlework shops.

Whether you work with cut strips or with commercial rug yarn, the amount needed may be judged roughly on the following scale: $\frac{1}{2}$ pound of cut fabric or $1\frac{1}{2}$ to 2 pounds of yarn to cover 1 square foot of backing.

Select a piece of foundation backing approximately 32 x 48 inches and lay out the rug design on it. Such a design may be drawn freehand or may follow a commercially manufactured pattern. Some backing comes with a pattern already stenciled on it, but it's more fun to create your own design. In this case take a saucer approximately 4 inches in diameter and lay it on the backing at one corner. Using the saucer as a guide, draw a circle. Repeat this process until the entire foundation is covered with circles, each of which touches adjacent circles. This is the so-called "cobblestone" pattern common to many antique hooked rugs.

Making the rug itself is now simply a matter of following the prepared design, using different colors in adjoining areas. This is not a difficult process. The foundation material is coarsely woven to allow for passing the rug yarn or strips in and out. Simply hold the hooking tool above the foundation or backing with one hand while holding the fabric strip or yarn below with the other. Push the hook down through the backing, pick up a loop of the material, and draw it back up through the foundation. This will create a loop on what will be the rug surface. Insert the tool a second time as close as possible to the first point and repeat the process. Each loop should be given a slight clockwise twist as it is drawn through the fabric to make a firmer surface. All loops should be of approximately the same height: about ¼ inch above the foundation surface. Be sure to pull ends through to the top when finishing a strand.

As the rug develops, you will note that adjacent loops of fabric support each other and create a firm surface, or pile. Some rug makers prefer to trim the surface of the rug by cutting off the heads of the loops. Such "shirred" rugs have an almost mosaic quality. If you choose to do this, be sure to clip no more than the very top of each loop; otherwise with wear the rug may come apart.

The rug pattern shown here may be worked in only two colors—one for the circles, the other for the areas between—but it is more interesting to use several different

shades in order to achieve a dazzling geometric scheme. Alternating rows of color, such as blue and gray, for example, can be extremely interesting.

Most rug makers prefer to stitch a 1-inch-wide rug binding about the edges of the foundation prior to hooking, allowing room for a seam and a backing if desired. Once you have filled the entire surface of the foundation with loops and completed the rug pattern, you can trim off the excess binding, turn it over the edge of the foundation and slipstitch it to the back of the rug. Not all rug makers use bindings, but they generally assure a longer life for your creation. The reverse of the foundation may be covered with a protective fabric backing or, if for floor use, with nonskid material. In any case, you now have an attractive and serviceable floor covering or wall hanging.

REVERSE PAINTING ON GLASS

Reverse glass painting is the process of painting a picture backward on what we would call the "bottom" of a piece of glass. In the end the finished product is preserved from damage and can be viewed through the clear, shiny shield. The technique is much less difficult than it sounds and was widely practiced during the last century. Today, unfortunately, few are aware of the procedure.

Equipment and Materials

Select a sheet of clear glass suitable to the size of the painting, in this case about 6 by 8 inches. This may be window glass or just a piece of glass removed from an inexpensive picture frame. The latter is preferable since once the piece is completed it can be reframed. Also required are tracing paper, cellophane tape, a fine felt-tip pen in black, turpen-

tine, and a selection of artist's oil colors. Aluminum foil for "tinsel" paintings is optional.

Transferring the Design to Glass

While many reverse glass paintings were done freehand, this procedure is rather complex, and most people today choose to copy historic prints, needlepoint designs, or even quilt squares. A design to copy is provided here, though you may prefer to use one of your own choosing. In either case the technique of transfer to glass is the same.

First, lay a piece of tracing paper over the chosen design and carefully trace it line for line, including all those elements you wish to include in your picture. Thoroughly clean and dry the piece of glass; then tape the traced pattern, wrong side up, to the center of the glass. Next, turn the glass over and with the pen copy all lines of the design on the surface of the glass. The tracing may then be removed, leaving a complete duplication of its design on this side of the glass.

Painting the Picture

The reverse painting should be done on the side of the glass where the inked outline appears and should follow this outline. Choose whatever colors you wish, or if you have copied a colored print or design, you may duplicate its color scheme.

In this technique the background is painted first; carefully fill this in, using flat colors. Black or ivory white were popular with 19th-century reverse painters. Background paint should be worked all around the central design and into the open areas between the design elements. Try to avoid getting paint on the design lines, but if this should happen, you can remove the paint with turpentine and a clean cloth.

It's best to do the background in two coats, the first of which should be thinned with turpentine so that it will spread easily. The second coat (applied after a day or two of drying time) should be thicker to supply an opaque effect.

Design elements such as flowers, buildings, figures, etc., should next be painted in. Again, the first coat should be a thin one, with thicker coats added to achieve shading and color depth. When all paint has been applied, the picture should be allowed to dry for a few days. It should then be backed with thin wood or strong cardboard and framed with the painted side facing the backing.

Tinsel Painting

Some artists employ a background of crushed "tinsel" to provide a sparkling effect in reverse glass paintings. If you wish to do this, select those areas where you want the foil to show through, such as windows, areas of sky, flower petals, and the like, and paint these spots only as a thin wash, not to the point of opacity. Next, a piece of ordinary aluminum foil should be gently crumpled and then straightened, leaving the creases. Tape this foil to the painted side of the picture before backing. The foil will show through the light areas in the composition and will reflect light in a dazzling manner. Victorians called such works tinsel or pearl paintings.

STENCILING ON VELVET

The use of stencils to apply blocks of color, so reminiscent of grade-school art classes, may seem rather simplistic to some, but for many years artists have employed stencils to create unique and effective works of art. In some cases many standard stencil forms—curves, squares, circles, and the like

—are combined in various ways to make entirely original compositions. In the 19th century such pieces were termed "theorems" because of the theorem, or problem, their creation involved. Our project does not call for several stencils but a single large one.

Equipment and Materials

One should have tracing paper, pattern paper, a ruler, pencils, glue, a #11-blade mat knife, stiff stencil paper, masking tape, acrylic paints, and assorted stencil brushes. A piece of off-white or tan cotton velveteen, measuring approximately 9 x 11 inches, will also be needed.

Making the Stencil Pattern

Study the illustrated design. Note how the overall picture is broken up into many separate elements divided from one another by areas of white paper. Copy it onto pattern paper

ruled in 1-inch squares. Then place some tracing paper over the pattern and trace it. Glue the tracing to a piece of stencil paper cut to size.

Cutting the Stencil

Place the stencil paper and attached tracing on a hard surface, preferably glass or marble. With the mat knife, cut away all shaded areas. The knife should be held at a slight angle, all cuts made toward you. Try to cut out each section with a single stroke to avoid rough edges. It's a good idea to practice some cuts on scrap paper before starting the real thing. Cut slowly and carefully to avoid errors.

Painting the Picture

The cotton velveteen should be taped to a table top or other smooth surface. Once the material is smoothed flat and all wrinkles removed, the stencil pattern should then be taped to the center of the cloth.

Now you are ready to paint. The acrylic paints should be used at full strength and several brushes of varying widths should be employed. Dip the brush into a color, picking up a small amount on the brush tip. Then wipe the brush on scrap paper until nearly dry. Holding the brush in a vertical position, work the remaining paint into the material with a circular dabbing motion. In larger areas always begin at the edges of the space to be covered and work toward the center. Where it is necessary to darken or shade a spot, go over it with more coats of paint. In no case should wet, full-strength paint be applied to the cloth.

Choose colors that are pleasing to you and fill all open spaces in the stencil. Protect areas that are not being worked on at the moment by placing a piece of paper over

them. Once stencil painting is completed, the composition should be left to dry for a day or two. The stenciled cloth can be mounted by centering it over a piece of cardboard, lapping 1 inch of material over the backing on all sides and securing it with tape. Make sure that there are no wrinkles in the material.

Velvet pictures should be framed under glass as they are quite fragile, but once properly shielded they will last for years.

CUTTING A SILHOUETTE

In the days before the camera there were few ways for people to record their features or those of their loved ones for posterity. There were portrait painters, of course, but their work was usually too expensive for the average citizen. As a result, many employed professional silhouette-cutters who for a few pennies and in a few minutes could render reasonable "shadow pictures" of friends and family. The technique is easily mastered, and today, as in the 19th century, many amateurs also practice this art.

Equipment and Materials
One should have several large sheets of white tracing paper, construction paper in both black and white, a strong light source, white paste, masking tape, a soft pencil, straight scissors and cuticle scissors, brushes, and water colors.

Taking the Likeness
Tape a piece of white tracing paper to a flat wall. Place your subject in front of this, preferably in a seated position.

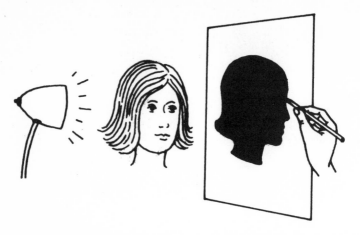

Put a strong light behind his or her head so that a clear, sharp shadow of head and neck is cast on the tracing paper. It will be necessary to move the light back and forth until a shadow of the right size and clarity is obtained. Profiles are most characteristic, so ordinarily the person whose likeness is being done should sit sideways to the light.

Once positioning is satisfactory, trace the shadow line of the nose, chin, and front of the face with your pencil. Then trace the back of the head.

Cutting the Silhouette

When a satisfactory likeness has been obtained, cut the silhouette out of the tracing paper and use it to transfer the subject to white or black construction paper. Lay the cutout on the construction paper, taping or holding it firmly in place, then lightly trace its outline on the construction paper. The final silhouette may then be cut from the stiffer paper. Follow all outlines as closely as possible and avoid cutting into the body of the silhouette. Use cuticle scissors when cutting in curved areas.

Finishing the Silhouette

The silhouette may be mounted on heavy cardboard of a contrasting color. White silhouettes are traditionally set upon a black background, but any dark color, such as deep green, brown, or red, will do as well. A black silhouette should normally be mounted on a white ground.

You may embellish your silhouette in several ways. Using small, narrow-tipped brushes and ordinary water colors, you may add eyebrows, hair, eyes, and other personal characteristics to an all-white silhouette, as was often done in the last century. Tiny cutouts of gold or silver foil may be used to represent jewelry or glasses. In short, don't hesitate to make the likeness as personal as possible.

Once properly mounted, the silhouette should be framed under glass, and it's a good idea to write some information about the person portrayed and the date of preparation on the back of the piece. After all, it's just possible that someday your silhouette might be a cherished heirloom.

WEAVING A SPLINT BASKET

Basket making is one of the most interesting and pleasant of all crafts. Small wonder that most of us have fond memories of being taught how to make willow mats or bowls at school or in summer camp. Splint baskets are really no harder to produce than those of willow, yet for some reason most people have little opportunity to practice this craft.

Equipment and Materials

A basket maker should have a penknife, sandpaper, and a tub of water in which to soak splint. Basketry splint was

traditionally cut from ash or hickory logs and shaved to size with a draw knife. Today it may be purchased in most craft stores or may be ordered from several national suppliers who advertise regularly in such publications as *Hobbies* and *Craft Horizons*. One should purchase 2 or 3 pounds, both thin splint (about 1/64 inch in thickness) and thicker pieces (about 1/32 inch), all approximately 3/4 inch wide, with individual strands varying in length from 2 to 4 feet.

Preparing the Splint

Examine the splint for rough spots. Where there are ragged areas or small strands split away from the main body of the splint, the knife and sandpaper should be used to trim and smooth the wood. Once this is done, soak the splint in water until it is quite pliable. This should take no more than 20 minutes. Do not oversoak; this will cause the splint to become soft and separate. If you want to artificially "age" the white splint, pour some old coffee grounds into the water. These will stain the splint an attractive light brown color.

Weaving the Basket

A splint basket is composed of two basic elements: verticals (called "spokes") and horizontals (called "fills"). Use the thicker pieces of splint for the spokes, the thinner, more flexible ones for the fills. To begin, choose a smooth, uncluttered work space on floor or table. Lay out 24 spokes, one on top of the other so that they resemble the spokes of a wheel (see illustration). Note that one of these spokes should be split in order to provide the uneven number necessary to achieve proper weaving. These pieces may be held in place, if desired, by pushing a long straight pin through the center of the pile (the hub of the wheel) and into the surface below.

warp split

Next, take a shorter piece of filler splint and weave it through the spokes, over and under, bending it into a circular form around the hub of the basket. Add additional pieces of thin splint as required, lapping them over the ends of preceding pieces and each time increasing the circumference of the basket bottom.

When the base of the basket is large enough to suit you, bend the spokes upward to the angle you want the sides of the basket to take and tie them loosely in place with a piece of string. Continue to weave the fillers in and out to make the sides of the basket.

Topping Off

When the sides are as high as you wish, double the last fill; that is, use two pieces rather than one for the last woven

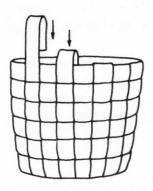

portion of the basket wall. Then trim the spokes off evenly about 2 inches above the rim of the basket. Bend these ends down over the rim and tuck them neatly into the second-highest band of fill.

Finally, select a thin and quite flexible piece of fill; tuck one end of this into the top rung (the highest band of fill), then loop it around the rung, completely covering the top of the basket. Tuck the end under the highest band of fill. This will bind it all firmly together and provide an attractive terminal point for your work. The basket is now complete. With care it should last for years.

A CORNHUSK DOLL

Though cornhusks have been used for many things, from baskets to mule harnesses, they are most frequently found today as material for quaint dolls made primarily in the Appalachian Mountains.

Equipment and Materials

Scissors, string, fine felt-tip pens, fabric dyes, white pipe cleaners, liquid dishwashing detergent, needle, and thread will be required. Cornhusk material should be selected not from the leaves of the plant itself, for these are too coarse and brittle, but from the more tender sheaths that protect the ear. A small amount of corn silk will also be needed.

Preparing the Husks

Since the husks are always worked on while wet (it makes them more flexible), they should be soaked in warm water for 10 to 15 minutes before using. If they are too green, they may be whitened by adding ¼ cup of laundry bleach to the water. For colored husks, put 2 teaspoons of fabric

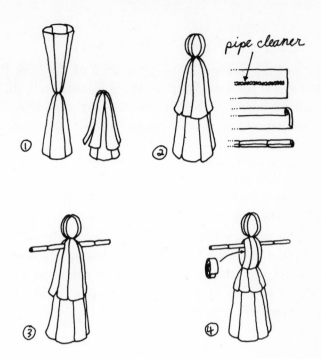

dye in a large bowl and add hot water and a couple of drops of detergent. Dip the husks into this solution a few times to obtain lighter shades or soak them longer if a darker color is desired. Be sure to rinse in cold water after dyeing.

Making the Doll

After soaking the husks, cut off the pointed ends and arrange a half dozen or so in overlapping layers. Tie this bunch tightly together at the center with a piece of string, turning the top portion of the husk bundle down over the string. This forms the body of the doll.

To make the doll's head, bind another piece of string around the husks about 1 inch from the top, leaving a small ball-like shape above the tie. A thin strip of husk may be wrapped in a bow around the string to conceal it from view.

The figure's arms are made by rolling a husk around a

piece of pipe cleaner, keeping the ends of the husk turned in to conceal the wire. Once wrapping is completed, the arms should be bound at both ends and in the middle. As an alternative one may braid three husk strands around the pipe cleaner.

Arms are added to the figure by forcing aside the body husks on opposite sides of the doll just below the neck and then inserting the arm rod. Once the doll is completed the flexible arms may be adjusted to any desired position.

The upper body of the figure is filled out by rolling up a small piece of husk and sliding it in among the body husks just under the arms. Once this is done the waist should be indicated by binding the husks with more string at waist level. The doll's body is now complete.

Dressing the Doll

Cut two ¼-inch strips of cornhusk and lay these over the shoulders, crossing them in front and back and attaching them either by sewing or by binding with string at the waist. These will represent apron straps. Traditionally, cornhusk dolls were made entirely of natural-colored husks, but your doll will be much more interesting if this and other parts of the dress are made of husks dyed in contrasting colors.

Once the straps are in place, select several wide pieces of husk, cut them to a point at one end and place them about

the figure's body front and back with the pointed ends extending down at waist level. Tie these husks in place with string, then fold them down over the waist to make the skirt. Trim the skirt ends evenly, and the doll is complete.

After the figure has had a day or two to dry thoroughly, the face may be painted in with felt-tip pens, and hair can be fashioned from corn silk sewed or glued to the head.

MAKING A SEASHELL-FRAME MIRROR

The abundance of seashells, as well as the great variety of shapes and colors, makes them a natural source of craft material. Shell work is practiced throughout the world and has been a popular American art since the early 18th century.

Equipment and Materials

You should have a large plastic sheet to use as a work surface, and you will need a pair of needle-nose pliers, tweezers, a ruler, a mat knife or single-edge razor, white glue, sponge, masking tape, a frame about 16 inches square, and a framed mirror, no more than 8 inches square. Rectangular, round, or oval frames also may be used as long as both the outer frame and the framed mirror are the same shape and the basic size difference between the two frames is maintained.

Try to find a large variety of shells in many different sizes, shapes, and colors. This will greatly add to the interest of your composition.

Gathering the Shells

Many types of seashells may be obtained, already cleaned and prepared for use, from craft shops or tourist shops in coastal areas. If you wish to gather your own, look for

such common bivalves as blue mussels, hard-shell clams, whelks, limpets, snails and even barnacles. You can find a greater variety of shells in warmer waters. Avoid shells containing live occupants; these are difficult to remove and can create unpleasant odors if not detected.

All shells should be thoroughly cleaned before use with warm soapy water and a soft brush (a toothbrush is excellent). With convoluted shells, such as those of the snail and conch, be sure that no particles of the animal remain in the inner recesses of the shell. After washing, the shells should be allowed to dry throughly before they are used.

Making the Frame

Measure the larger outer frame carefully. Using a mat knife and ruler, cut out a piece of cardboard or mat board the same size as the frame. Then, in this same mat, cut out an opening the size of the smaller inner mirror frame. Place the framed mirror in the opening in the mat board and fix it in place with strips of masking tape running across the back of both mirror and mat. The mat board should then be fitted into the larger frame and secured with tacks or small nails.

Preparing the Shell Arrangement

You may decide on your shell design before gluing it into place or simply create it as you go along. In the former case shells should be arranged on the mat between the outer frame and the mirror until you have a complete and satisfactory composition. They should then be removed and set aside in the same order, then glued carefully back in place, a few at a time.

This procedure, as you can readily see, involves several steps and quite a bit of time. It's really a lot more fun to

seashell mirror

make up your design as you go along. Start working at the frame of the inner mirror, preferably covering this with small circular shells. Be sure that these overlap so that none of the mat board can be seen. Next, work gradually out toward the edge of the larger frame, increasing the size of the shells as you move away from the center. Very small shells may be handled with tweezers. Try to vary the color of the shells used as well as their form. Glue most shells top up, but some, such as mussels and clams, should be attached top down to display their pearly interiors. Make sure that all shells are firmly glued in place, but avoid getting glue on their visible surfaces. If this does happen, white glue is soluble in water and may be wiped away with a bit of damp sponge. The illustration shows one completed section.

Some people prefer to cover the entire finished composition with a coat of light shellac (no more than 1 part clear shellac to 5 parts solvent) as this protects the shells and gives them a sheen. However, this procedure is not necessary and is purely a matter of choice.

A BOUQUET OF DRIED FLOWERS

Dried flower and foliage compositions were a great favorite with the Victorians and offer similar joys to this generation. A few of the earlier creations, preserved under glass or in shadow-box frames, have come down to us, but generally the material is so fragile that each succeeding generation must create its own arrangements.

Equipment and Materials

One should have scissors, a sharp knife, twine, and florists' materials such as stubb wires for stem making, gutta-percha tape, and blocks of foam or plasticine for fixing the arrangements in place (available from a florists' supply house). Hair spray will be needed to preserve the foliage, and a basket, vase, or bowl will serve as a container for the composition.

Obtaining and Drying the Flowers

Many different types of flowers and parts of plants can be used in dry arrangements. Some, of course, are more suitable than others. Certain "everlasting" flowers such as the popular strawflower are particularly favored because they maintain their form and color so well after drying. Other similar types are the pearly everlasting, globe amaranth, sea lavender, and yarrow. Among the so-called "soft" flowers,

goldenrod, cornflowers, delphiniums, sunflowers, and roses work very well when properly handled.

Decorative seed heads, fruits, grasses, foliage, and small gourds may also be used in dried arrangements. The selection is limited only by opportunity and imagination.

Flowers and other materials for dried arrangements may be purchased, but drying them yourself is as easy as it is fun. They should always be gathered on a dry, warm day, never when the plants are damp. Select flowers just before they come to full bloom, as fully opened blossoms will disintegrate as you attempt to preserve them. Cut selected material from the plant with a sharp knife or scissors. Do not pull or break the flowers off.

After picking, remove all leaves from flower stems. Tie the blossoms in small bunches, using heavy thread or twine and leaving a small hanging loop. Hang the bunches of flowers, well apart and head down, from hooks or a long piece of rope in a dry, dark, and airy location. Too much sunlight fades the materials, and damp causes mildew. The required drying time varies: Grasses take no more than a week, while larger and heavier flowers may need as much as three weeks to be dried out thoroughly.

Creating the Floral Arrangement

First, spray all seed heads and berries with hair spray and allow time to dry. Next, select a container and press a lump of plasticine into its bottom as a base for the arrangement. The plasticine will remain soft long enough for the stems of the flowers to be pushed down into it. As an alternative you may choose to use a piece of florists' foam cut to fit the container. Since this foam is very light, it may tend to tip over, but this can be remedied by gluing it to the container

or cutting a hole in the bottom of the piece of foam and inserting a weight such as a piece of stone.

Select a quantity of each material—flowers, leaves, berries and the like—that you plan to use in your design. If stems are too short or too delicate to support the flower heads, lengthen or reinforce them with pieces of 19- or 20-gauge florists' wire. These additions may be hidden by wrapping them with gutta-percha florists' tape. Single strands of this wire may also be used to support a drooping leaf or petal. The wire should be placed along the center back of the leaf and held in place with clear tape.

While floral arrangements should reflect your own taste and preference, there are certain basic principles you can follow to assure an attractive composition. First, compose an outline by placing three tall pieces, one in the center of the container and one at each side, creating a triangular effect.

The stronger or more spectacular flowers—those that make up the focal points of the design—should be placed next, near the middle of the container and rather low down. Then, filler material such as grasses or leaves can be used to unite the focal points and the basic outline. Don't feel that you have to fill up all the space. A true harmony of line and color is much more important.

While fragile and quick to disintegrate with improper handling, dried flowers treated with respect can last for several seasons, and the same pieces may be used over and over in different arrangements.

PAPIER MÂCHÉ BOOKENDS

The craft of papier mâché (from the French for "chewed paper") is very old. It was well known to the ancient Chinese

and was practiced throughout Europe in the 18th and 19th centuries. The materials are easy to obtain, and the skill is quickly learned.

There are two basic methods of working with papier mâché. In one, several sheets of newsprint are soaked in a mixture of glue and water, then folded into various shapes. The other technique, the one we will use here, calls for mixing soaked shredded paper with glue and modeling forms from the mixture.

Equipment and Materials

Newspapers are the basic material in the making of papier mâché. Keep a good supply on hand. You will also need P.V.A. glue or a good supply of cellulose wallpaper paste. Both can be obtained from hardware stores or craft shops. For finishing you will want carpenters' glue, powdered chalk, sandpaper, tempera or gouache paints in different colors, as well as several paintbrushes. Finally, for this particular project find two stones, each about 8 inches high and roughly triangular in shape.

Preparing the Papier Mâché

Cut several pounds of old newspapers into small (1-inch-square) pieces and allow them to soak in warm water for several hours. When the paper is thoroughly soaked, remove it from the water and squeeze out the excess liquid. Place this pulped paper in a large glass or metal bowl and add P.V.A. glue or cellulose wallpaper paste. The wallpaper paste should be mixed with water until it thickens enough to stick to your hand. Add the glue or paste to the pulverized paper a bit at a time, working it in until the mixture sticks to itself and is easily handled and shaped.

Molding the Bookends

Select one of the rocks and stand it on end with the larger side down. Take several handfuls of the pulped paper and apply them to the stone, covering its entire surface. As you mold the material, be sure that the back of the composition is left flat to support the books. The bottom also should be kept flat to provide a stable surface. A board may be used for a work surface. The papier mâché may be sculpted into

three mushroom shapes, as seen in the illustration. The largest one, in the center, is built around the stone; the other two are constructed entirely of pulped paper. Once the piece is formed to your satisfaction, let it dry for several days.

Finishing

Heat a cup of carpenters' glue until it flows freely. Then add to it about a cup of powdered chalk, stirring until the mixture is rather thick but will still brush out. Coat the entire bookend, including the bottom, with this mixture. Again, set the piece aside until thoroughly dry. When dry, the surface should then be sanded to remove all irregularities. Several coats of the chalk-glue mixture may be applied (thoroughly dried and sanded between coats) for greater protection of the piece.

Painting

Select suitable tempera or gouache paints (brown, red, and yellow are appropriate colors) and mix in a small amount of P.V.A. glue, which will serve to waterproof the piece and to give it a glossy finish (the paints would dry to a mat finish). With a ½-inch-wide brush paint the bookend in several colors, starting at the top and working downward. Be sure to wait for each color to dry before applying the next one. You may want to have brushes of various sizes on hand for different colors and areas. Repeat the entire construction process with the other rock, and you will have a complete set of attractive and serviceable bookends.

PAPER PASTING

Pasted-paper decoration or decoupage is an interesting and easily mastered craft. In the past everything from cigar

labels to postage stamps and envelope liners has been used to create decoupage, and the objects decorated range from tiny trinket boxes to full-size pieces of furniture.

Equipment and Materials

As basic decoupage tools one will need 2 pairs of scissors—regular paper shears and cuticle scissors for fine details—rubber cement, white glue, sponge, steel wool, a 1- or 2-inch brush, shellac, alcohol solvent, furniture wax, and a sealing substance such as clear acrylic spray. For wood items, turpentine, paint remover, and sandpaper may be required; for metal objects, an oil-based primer and paint.

The objects to be decorated may vary in size and shape, but it is best to work on wood or metal and, at first, with objects of a basically rectangular form. Boxes are particularly suitable and readily available. Tin cans and glass bottles or jars may also be used. Decorative material may be collected from many sources. Magazine photos, old book illustrations, greeting and post cards, calendars, catalogs, wrapping paper and wallpaper are just a few examples of the available materials. Classic decoupage relied primarily on black and white illustrations, but most modern paper pasters prefer colored prints.

Preparing the Prints

The material chosen should be sealed with a waterproof sealer to prevent water and glue damage. Acrylic spray, which is readily available in craft and hardware stores, serves particularly well as a sealer. Simply give each side of the paper several coats of spray (allowing drying time between coats), or if you prefer, you may use a solution of 4 parts alcohol solvent to 1 part shellac for this purpose. Use standard, straight-bladed shears to cut away excess

paper and short, curved cuticle scissors to cut around the forms. Finished design elements should be stored in envelopes until used in order to prevent their being damaged.

Surface Preparation

For best results decorative paper should be pasted to a clean, dry surface. Painted wood objects should be washed in turpentine to remove grease, and the surface should then be lightly sanded. If the paint is badly cracked or pitted, it should be removed with paint remover, and the bare wood should then be washed down and sanded. Bare metal may be cleaned with alcohol solvent and given a coat of oil-based primer, after which it should be painted in flat black, red, green, or any other appropriate color. Painted metal (after all rust is removed) may be treated in much the same manner as wood.

Fixing the Decorative Design

Select design elements from those previously prepared and arrange them on the surface of the object to be decorated. A small quantity of rubber cement will serve to secure the pieces temporarily while you work out your composition. Elements of the design may touch but ought not to overlap.

paper pasting

Try to create a composition such as a basket of flowers or a landscape. Once you have arrived at a satisfactory arrangement, glue the elements into place with a thin coating of white glue. Be careful to smooth out the surface of each piece of paper (working from the center toward the edges) so that no wrinkles or air bubbles will mar it. If any glue appears on the surface of the object or on the prints, it should be removed with a damp sponge.

Finishing the Job

After all pieces of the arrangement are glued firmly into place, allow it to dry for a few hours. Then cover it with 7 to 10 coats of shellac or varnish. These should be put on with a 1- or 2-inch-wide brush, wielded in long, even strokes, all moving in the same direction across the surface of the decorated object. Be sure that no bristles from the brush adhere to the wet surface and that there are no pools or streaks of finishing material. After applying each coat of shellac or varnish, allow a drying period of 8 to 10 hours. After application of the first 3 coats, successive coats should be lightly brushed down with fine steel wool to reduce tackiness and prevent too much shine on the surface. After the final coat has dried, wipe off the surface with a damp sponge. When it has dried, give the entire object a coat of furniture polish.

MAKING A BEAD BAG

Beadwork has generally been regarded as an Indian craft, but as a matter of fact beaded objects were made throughout the Victorian era by women of many ethnic backgrounds. The work takes skill and some patience, but the final product is well worth the effort.

Equipment and Materials

Tracing paper, scissors, a razor, ruler, pencil, gum eraser, glue, strong and fine sewing thread, and beading and sewing needles are required. For the body of the bag you will need a piece of chamois about 14 x 20 inches and glass beads, often called seed beads, in several colors. Beads and chamois can usually be found at local craft stores. Beads are sold by the bottle, and a good combination for this project would be 6 bottles of white beads, 2 of red, 2 of green, and 6 of blue.

Making the Bag

Using a pencil, mark the dimensions of the bag on the chamois. These should be approximately 6½ inches by 7¾ inches. Mark two separate pieces, one for the front and one for the back of the bag. Next, using tracing paper, trace the decorative pattern illustrated here. Once it is completed, darken the outline of this tracing by going over it again on the reverse side. Place the pattern on the chamois and carefully trace it out on the smooth surface of the leather. Chamois marks easily; by simply running your pencil over the tracing you will produce a clear pattern on the leather beneath it. Errors in tracing may be erased with a gum eraser.

This project is intended for the decoration of the front of the bag, but you can use the identical pattern on the back as well.

Beading

Cut out both front and back of the bag (this makes beading easier). The dots on the accompanying pattern represent the approximate number of individual beads to be used in a given row as well as the direction in which they should be sewed. Use a continuous strand of thread to attach the beads. To

blue

red

white

green

position the beads, place the beading needle, with the thread knotted at each end, on the chamois at the first line of beading. Make a loop through the leather to begin, then string on the number of beads required to fill in the line. Next, run the needle through the chamois at the end of the line so that the string of beads lies flush with the surface. Repeat until design area is filled. As you finish each row, take small couching stitches with regular needle and fine thread, over the beading thread between the beads, to hold them individually in place. Beads should be placed evenly and in a straight line. For additional strength the beading thread should be secured with several loops at the end of every three rows. The center portion of the design should be beaded first and then the border.

Finishing the Bag

Once all beading is completed, line the bag by cutting out two more pieces of leather, each ¼ inch smaller on all sides than the exterior portions. Glue the rough or "wrong" side of each interior piece to the rough sides of the bag front and back and allow to dry thoroughly. Next, on the right side sew the side and bottom edges of the bag front and back together with short buttonhole stitches. Cover the seams by sewing beads over them as follows: Run beading thread through the leather over the end of the seam, string on 6 beads, stitch diagonally over the seam so the beads form a short loop, draw the needle out on the other side of the seam and repeat until the seam is completely covered.

Making the Drawstring

Using a razor, cut six 1-inch-long vertical slots in the upper area of the bag, starting 1 inch from the seam and spacing openings 1 inch apart on front and back. Cut out a strip of

chamois 1 ½ inches wide and 20 inches long. Fold it length-wise and stitch the edges together to make a tube ¾ inch wide. Trim the seam allowance and run the drawstring in and out of the slits in the top of the bag.

A WAX BASKET

Wax work—from the full-size human figures of Madame Tussaud to the small replicas of apples, peaches, and pears that once crowned Victorian mantelpieces—has always been a popular American craft form. Materials are readily available and readily shaped, and the finished product can look startlingly realistic, as anyone who has ever visited a wax museum knows. Figure shaping is time-consuming and requires much skill, but other objects can be made by following a few simple directions. One of these pieces is the wax basket.

Equipment and Materials

One should have a wire or wicker basket approximately 12 inches across and 8 inches deep. Wire baskets may sometimes be found in craft shops, and a variety of wicker baskets are available at oriental import stores. A dozen or so pieces of soft wire, about 4 to 6 inches in length, and some heavy twine are also needed. Pliers will be helpful for shaping the wire, and epoxy or white glue for attaching other decorative elements such as pine cones, twigs, leaves, dried berries, and nuts.

The basic working material will be 1 pound of candle wax or paraffin. The former can be found in hobby shops, the latter in most grocery stores. For color one can use commercial wax dyes, also available at hobby shops, or a few common colored wax crayons.

Preparing the Basket

Bend the short wires in, out, and around the basket and its handle (if any) in loops, bows, and the like so as to create an irregular surface of varying depth. Wrap the twine at random around both wire and basket and glue the other materials, such as pine cones and dried leaves, to the base thus formed. Attempt to create an interesting surface. This may be either naturalistic and freeform or rigidly structured, as for example, covering the entire basket surface with acorns or leaves of a similar type.

Preparing the Wax

When the basket is completed, allow time for glued-on elements to dry thoroughly. In the meantime prepare the wax. Be very cautious with the hot wax; it is extremely flammable. The safest way to prepare it is to melt it in the top of a double boiler. For color add commercial wax dyes or about half a crayon. If a crayon is added, do not use the dregs of the wax; they will contain sediment which will affect the color of the basket. Stir the color into the melting wax until it is thoroughly and evenly colored.

Decorating the Basket

Pour the hot colored wax into a flat tray large enough to accommodate your basket, keeping wax and tray well away from the heat source. As the wax cools, roll the basket around in the sticky substance, which will adhere to it. If you wish to have several different colors mixed into your creation, it will be necessary to repeat this process several times. The basket should be allowed to dry between applications.

As an alternative technique, one may dip the basket into a large vessel filled with liquid wax. This process requires a good deal of wax, but the resulting finish is smooth and lustrous and quite different from that obtained by the rolling method. In either case once the basket is completely colored, it should be handled with care, as wax is quite brittle.

A wax basket may be used in several ways: filled with dried flowers, wax fruit, or nuts, it may be displayed as a centerpiece, a mantel ornament, or, in the 19th-century manner, under a glass dome or in the family china cabinet. It may also be used as a planter, particularly with ferns and ivy. In any case it will prove an interesting addition to your decor.

INDEX